W9-COL-129

INTROSPECTIVE WORLD

a photographic journey for the senses

– Dori –
Enjoy traveling the
Earth, seen thru my eyes
and soul!

Bill Bachmann

INTROSPECTIVE WORLD

BILL BACHMANN

Ernest & Conrad Publishing

Copyright, © 1995, 1996 by Bill Bachmann

All rights reserved. No part of this book may be reproduced or utilized in any form or by any means, electronic or mechanical, which includes photocopying, recording, or by any information storage & retrieval system, without written permission from the publisher and author. Inquiries may be addressed to:
Ernest & Conrad Publishing; Box 950077; Lake Mary, FL 32795-0077 USA

Second Edition 1996

Library of Congress Catalog Card Number 95-61327

Bachmann, Bill
 Introspective World

 1. Bachmann, Bill 2. Advertising - Film Industry - Photographers, Commercial - Photography - Fine Arts - Monuments of the World - Photographers - United States - Biography II. Title

ISBN 1-877659-02-9

Printed in the United States of America
1 2 3 4 5 6 7 8 9 10

Dedication

This book is dedicated to my mother, Helen May Bachmann. She was a career woman before the phrase was part of our vocabulary.

I have pleasant childhood memories of sitting on her lap as she typed her weekly newspaper column. She bought me my first Brownie camera, and has sparkled my life with her wit and intelligence.

Mom's love for photography and writing, her keen awareness of social causes, her integrity, and her idealistic persistency have been passed on in my blood, and I am forever thankful.

This book is for you, Mom, to share the *Introspective World* I have witnessed.

Books by Bill Bachmann

Clicking The Shutter Is The Easy Part

Introspective World

Images of Woman

Screenplay

One Dream Too Many

I take pictures. Nothing more. Nothing less.

I've shot pictures that, including expenses, cost clients hundreds of thousands of dollars. I've shot pictures for free. The amount of money doesn't change my goal. I shoot from the heart. And try to give something of myself with every click of the shutter.

It's a wonderful life... interpreting the world through a lens. When the viewfinder says "YES", I wouldn't want any other job in the universe.

Photography is my hobby... my canvas... my passion. More than that – it's my life.

Come share with me as we explore this *Introspective World*.

MONUMENTS
OF THE WORLD

This section of the book illustrates in words and photographs the greatest assignment I have ever attempted. With the sponsorship of Kodak films, I traveled for 295 days in 72 countries to photograph the 27 major monuments of the world.

The assignment actually started out simply. Because I am somewhat known in the photography industry, Kodak had been asking me for some time how they could use my name in association with their films. During one discussion, I stated, "Why not send me around the world?" And, as simple as that sounds, that was the start of my adventure. We met and discussed which of the monuments we should include, and how we would promote Kodak.

We then received tremendous additional support from Hilton Hotels International and Marriott Hotels, along with my stock agencies. I was able to rest very tired bones in wonderful hotel rooms from Hilton and Marriott. They also set up many press conferences, TV coverages, and magazine stories around the world.

My travels became very newsworthy, since a trip of this scope and magnitude had never before been attempted. No one else had ever traveled to all the major monuments of the world, with corporate sponsorship, to photograph for magazines and a book. I was one of the first photographers in the world shooting brand new films from Kodak, as I explored our planet.

My assistant and friend, Luke Potter, traveled with me to most of the corners of the earth. I could not have done this trip without Luke's help and friendship... it is hard to imagine the scope of this venture without his smile and love of photography. In my usual advertising work, we travel with large crews of models, make-up, assistants, art directors, and others – and get so many things done for us. In most of these eight trips of 30 to 50 days each, Luke and I traveled together "by the seats of our pants" and met the challenges together. We were not isolated by large crews, so our perspectives on people and places were close-up and intimate.

I thank Luke again, here, for all the grand experiences we shared, and the love of photography he shares with me. He was my student, my assistant, my friend... sometimes he was my guide and teacher. It is so wonderful to have a friend like Luke... his appreciation of various cultures often inspired me. His photography became better and better, and my respect for him as a person became stronger and stronger.

In all, I traveled over 214,000 miles in those 295 days over the two years this trip encompassed. I spent a total of 761 hours (32 entire days) in planes or trains, and 193 hours (8 days) just WAITING for them! Even more of a feat was that I survived 168 plane meals!

One good thing about this two-year trip is that we carried less than usual. We often carry up to 14 bags of cameras, lights, poles, reflectors and other gadgets, in addition to what the models, art directors, and crew members check onto planes... customs LOVES to see us! But on this venture, I narrowed this to a total of

three bags and a cart. I only packed two Nikons, one Hassleblad, and one panoramic camera in one bag, with film and clothes in the other two. What a relief to be without all that burden of equipment! And I totally trust my Nikons and Hassleblads... the most reliable cameras on this planet.

The trip had its share of troubles. I almost died when my appendix ruptured in Singapore (10 days in the hospital, and, unfortunately, Luke wasn't with me on that trip!). What a miserable time that was... I'll never forget the feeling of being all alone in the ER ready to be wheeled into the operating room. My doctor spoke only three words of English, "I cut you!"

Later on the trip, there were many more problems. A plane crashing – pieces barely missing me – into an apartment building in Amsterdam; surviving earthquakes in Egypt; bombings within blocks in England and Spain; flooding in France and the Midwest, USA; food poisoning in India; a plane running off the runway in Hong Kong in a typhoon; and other mishaps. This trip was definitely not for the timid.

Yet, as a photographer, all of these experiences are somehow forgotten when we get back to the USA and the film is developed. Fortunately, I only remember the places and people in positive ways.

As you travel through this World Monument Tour, you'll see three pages of individual photos that I took at each monument with local residents. These photographs were a wonderful method of INSPIRING me to meet and reach out to native people in many countries. Sure, I struggled with many of the languages, but I received much more than I gave. A smile is definitely understood in any language!

Each of the people in the photo with the poster also signed the print in his own language. The last page of this section is a copy of those signatures on the print. I value that poster, and the people I shared time with on many corners of earth.

There have been many magazine articles written about this trip, but this book is the first complete story of the travels. And after traveling to over 100 countries in my career, I can say that the people of the world have much more in common than they have differences. Our customs sometimes are strangely diverse, but each human with whom we share the earth wants five basic things: health, enough to eat, safety, shelter, and a better world for their children. All of the other luxuries, from Mercedes to Rolexes, really are only extras in the world. I find great joy in the common bonds we all share.

If I talk about people with me for photographs at the Monuments, remember to go to the end of this first section to see the photographs all together.

Sit back now as we visit everyone's "wish list" of all the major monuments of the world. I hope the respect I have for these special places mirrors in my photographs and echoes in my words.

Great Wall of China – Peoples Republic of China

You can't imagine how rare this photo is... the Great Wall without people! There are 1.1 billion people in China, and it seems that half of them bring their families each day to walk on the wall's 18-foot wide walkway.

The wall spans over 4,500 miles across terribly rough mountains. I marvel at this overpowering structure, all of the materials that were brought over the mountains, and the millions of man-hours needed for construction. It is the only man-made monument that can be seen from outer space. If only it had done a better job of protecting China from invasions!

Four places on this World Tour excited me most: Egypt's Pyramids, India's Taj Mahal, Moscow's St. Basil's Cathedral and the Great China Wall. Standing at any of the four totally captivates one's senses.

On the day before I shot this photograph, the wall was very crowded, and I wanted to have that rare photograph with no people. So I hired my cab driver, Xu Chang Li, and we left Beijing before dawn at 4 am. We drove into the mountains to this recently opened section of the wall in Mutiamya and arrived well before the trams opened. We climbed high into the hills in the early morning, arriving before anyone came to disturb our mission. I'm sure glad we did. Here you have early morning on the China Wall without a soul in the viewfinder!

I spent a total of six days with Xu Chang Li and came to admire his strength and wisdom. He was fascinated with my many cameras and techniques – and my willingness to meet and communicate with his people. He commented to me several times about how he liked that I really attempted to meet and talk to many people in the small villages, in addition to taking photographs. He loved that I wanted to include a photo of him in the book (it's in the back of this section).

I hope that our paths cross again in this world that seems to get smaller each day.

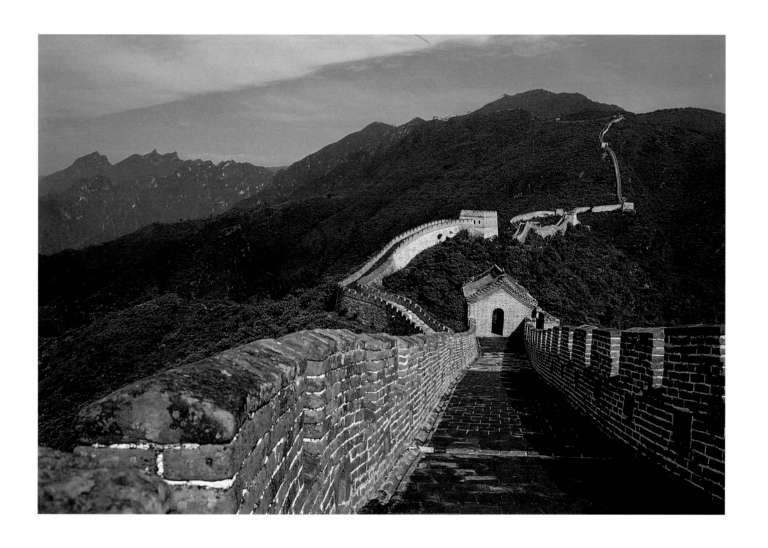

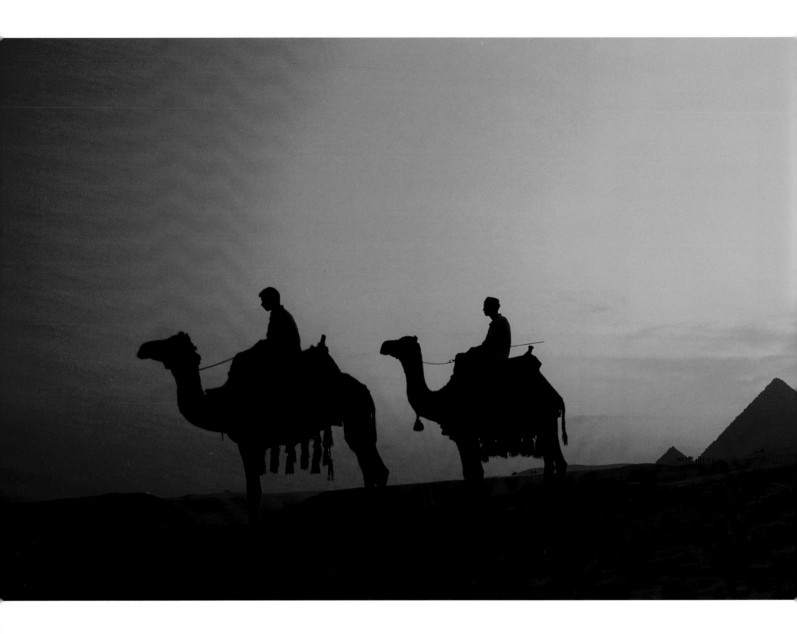

Pyramids of Giza – Egypt

These Pyramids are over 4,000 years old, and in several places you can walk into the interiors. It is not pleasant; rather smelly, cramped and musty.

The country of Egypt has many customs which appear strange to people in the West. There seems to be one rule about autos... the more expensive car has the right of way. I saw this so often. A Mercedes is allowed to almost knock a Fiat off the road. Then a Fiat can bump a bicycle. The bicycle runs over the pedestrian. No one complains; they just move out of the way!

Cairo is a large, busy city of 13 million people. I arrived right after the earthquakes, and was there during aftershocks, which turned much of the slums into rubble. And what wasn't rubble was covered with sand. You could write your name on all the car windows!

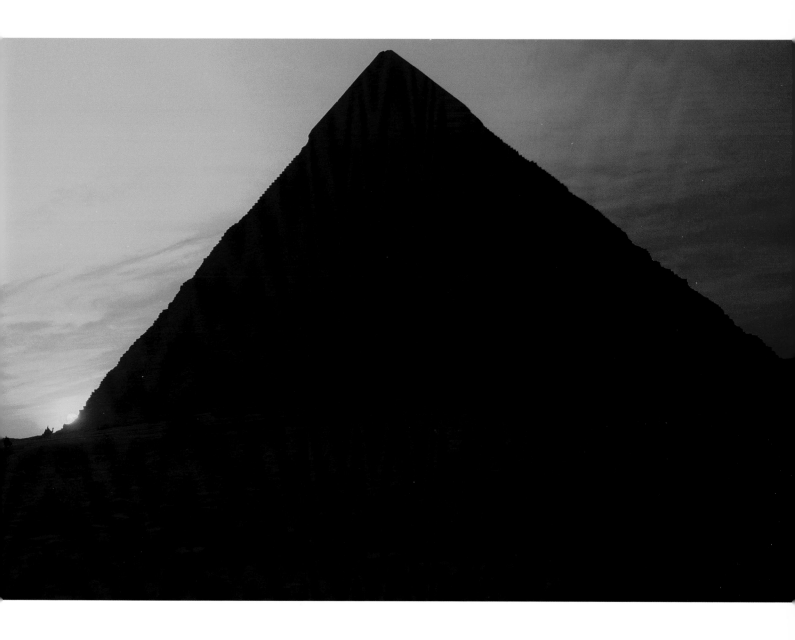

This is one of my favorite photographs that I have ever taken. I looked for two days to find the "angle" to represent the three great pyramids.

Naturally, the area from which I wanted to shoot was off limits, so I had to pay the police for permission (and escort) to shoot from this perspective. As I've often lectured, "Photography is often about waiting." I waited for over two hours for the sun to set behind the three pyramids. Frantically, I had to convince the two camel drivers to sit for me, while I created this timeless image of camels and pyramids.

I love this panoramic format... it "sweeps" the land and the golden colors are wonderful for the feeling of Egypt.

The Parthenon – Athens, Greece

Greece is an amazingly unique country. Italy and Egypt have ruins... Greece has RUINS!

The country lives concurrently with its past. Once the most influential country in the world, educationally and philosophically, it now relaxes in its Mediterranean surroundings. The age-old ruins bask delicately in the warm sunshine.

The Parthenon sits majestically high on top of the Acropolis hill in Athens – Greece's bustling, noisy capital. Yet, no noise can be heard here at the monument. The Parthenon's stunning pillars speak reverently to the soul of the visitor. It quietly symbolizes the power that was once Greece, centuries ago, when it was the center of the universe.

Having spent considerable time traveling in Greece, I can make several knowledgeable observations. The cars can not be driven without the horn working; Greeks can give up some habits, but definitely not cigarettes; and if there's an old building in a state of repair, the Greeks will put a fence around it and charge an admission! And, I may add, it will be worth the money.

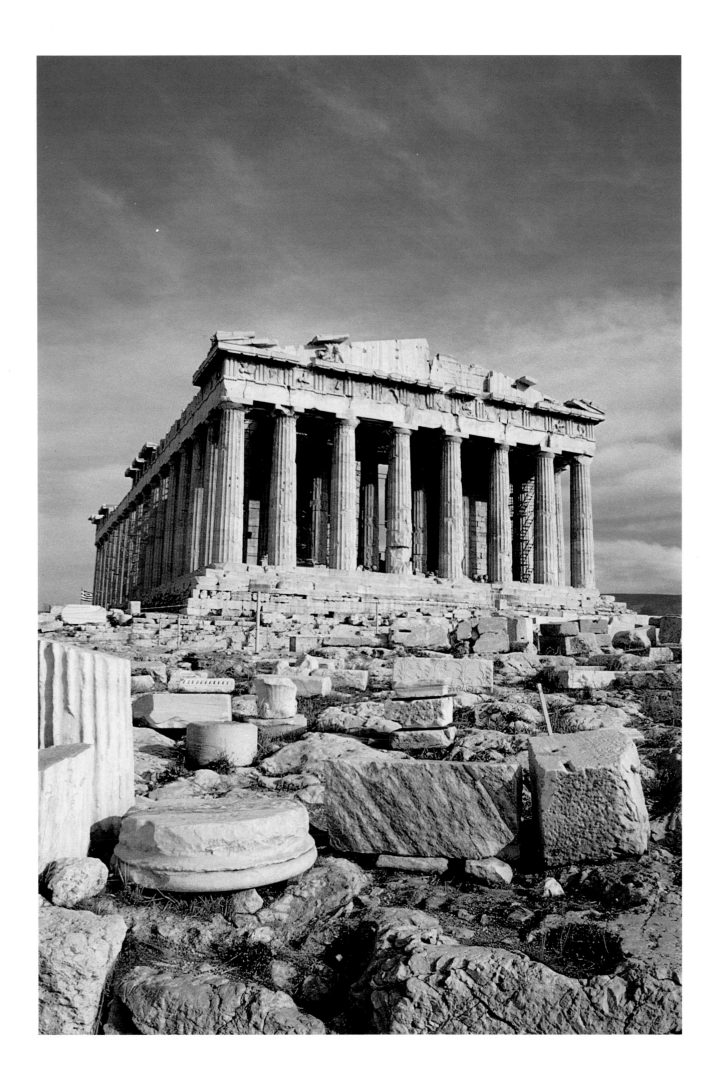

Big Ben – London, England

The most famous timepiece in the world sets the tone for life in London. Though not many things on earth are totally reliable, this wonderful clock chimes today as it did for many Kings and Queens, Winston Churchill and countless other rulers over the years.

I attended graduate school in London, so I've witnessed Big Ben in its special place at Westminster on the Thames in many diversified climates. I like it best on a foggy day – when the chimes penetrate the fog with a deep reminder that "all is well, things will get better."

Ah, the English... yes, they do seem a bit smug at times – rushing around on the Tube, heads riveted to the Times. And they hardly blink at Big Ben as they rush to work. But, in their souls, they are proud of their Big Ben and love its reliability and history – even as they argue about politics a stone's throw away in Parliament.

Each time I'm in London, I am drawn to this beautiful view. I stand where Winston Churchill stood, pondering England's fate, checking his pocket watch... and I can breathe history.

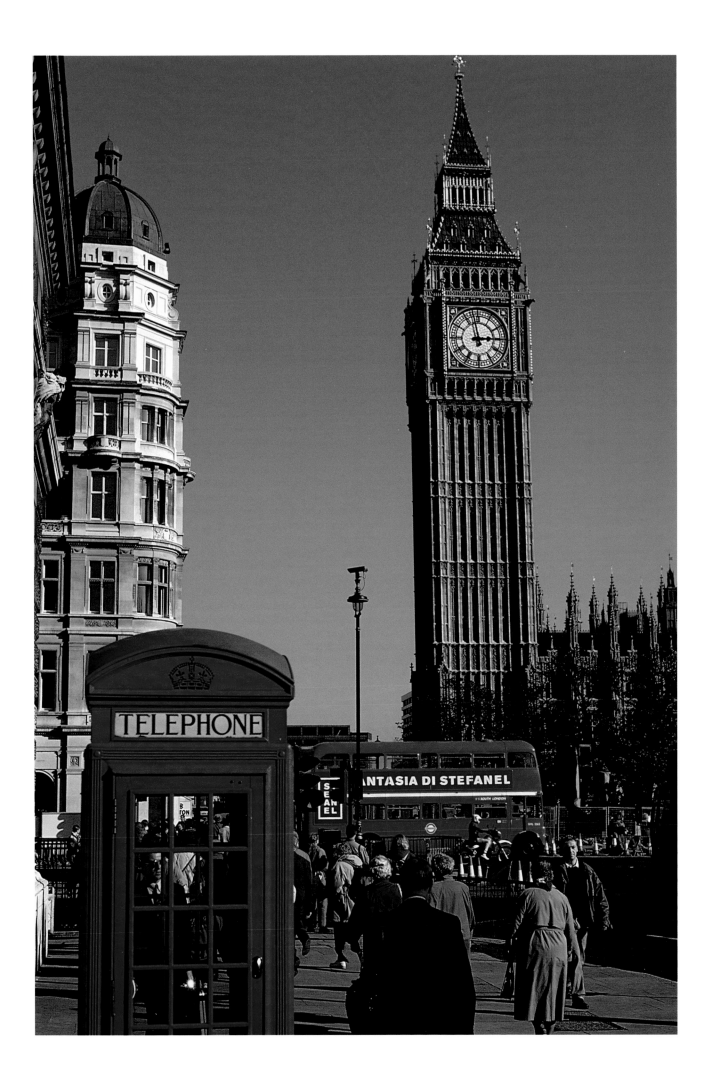

Statue of Liberty – New York

Whenever I visit the Statue of Liberty, I realize how spoiled we Americans are today. We take for granted something so valued around the world... our freedom, our liberty.

I prefer to think of how this magnificent lady looked to our ancestors as they came to Ellis Island. Lady Liberty must have looked wonderful to those tired and scared immigrants as they searched for a better life so far from the home they had known. She offered hope.

Now she's well over 100 years old and looks grand from a major facelift. Sadly, immigrants don't pass her anymore as they begin their American quest. And even more sadly, many New Yorkers have never bothered to come over to visit her.

I've photographed the Statue of Liberty from all sides, even hired a plane to shoot her from the top, in lots of different weather and degrees of repair. She still sends thrills through me each time I journey near. Yet, I'm most glad that she welcomed the hungry immigrants who helped mold our great country into the diversified blend it is today.

The couple pictured with me at the end of this section were soon to be parting. He is stationed in the military in Germany and she waits in New York City. I'm glad I happened to meet them here... she will think of him when she sees the statue. She sure isn't the first person to be inspired by this sight as she misses a loved one.

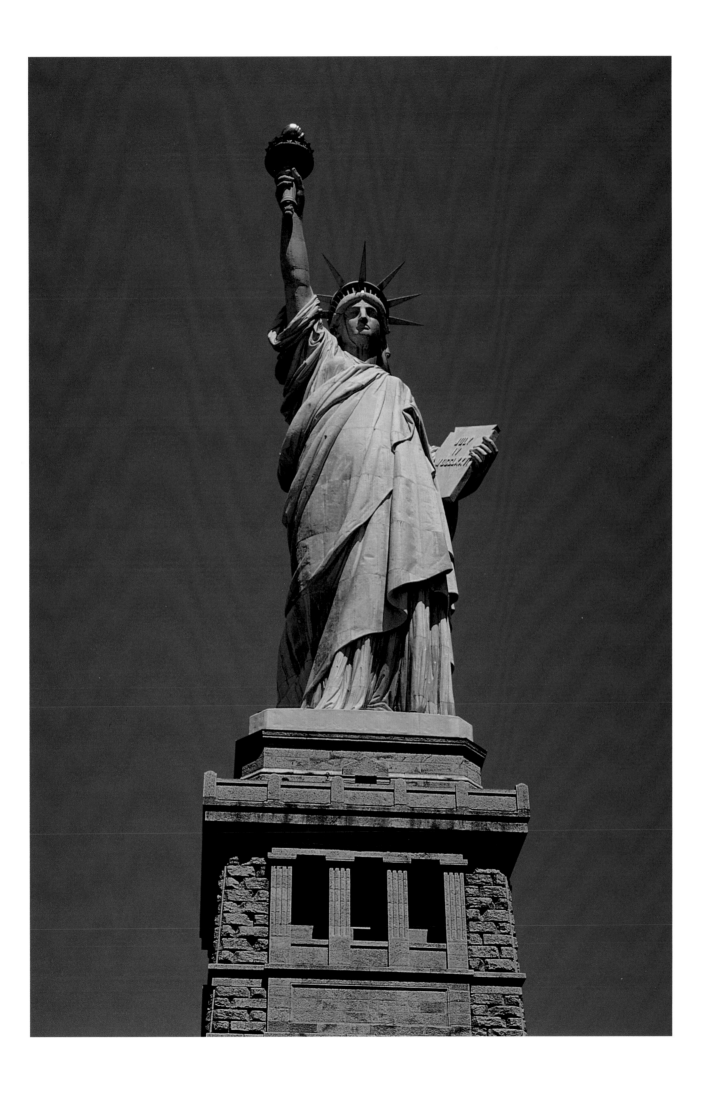

Corcovado Statue – Rio de Janeiro, Brazil

From a helicopter in the clouds, I captured the imposing statue of Christ in the mountains. This famous monument overlooks one of the most famous beaches in the world... Copacabana Beach.

Rio has its own identity, its own energy. Extreme poverty and wealth live precariously close together. Music and dance create vibrant energy and festive colors. The mountains, harbors and statue are a view you should see once in your life.

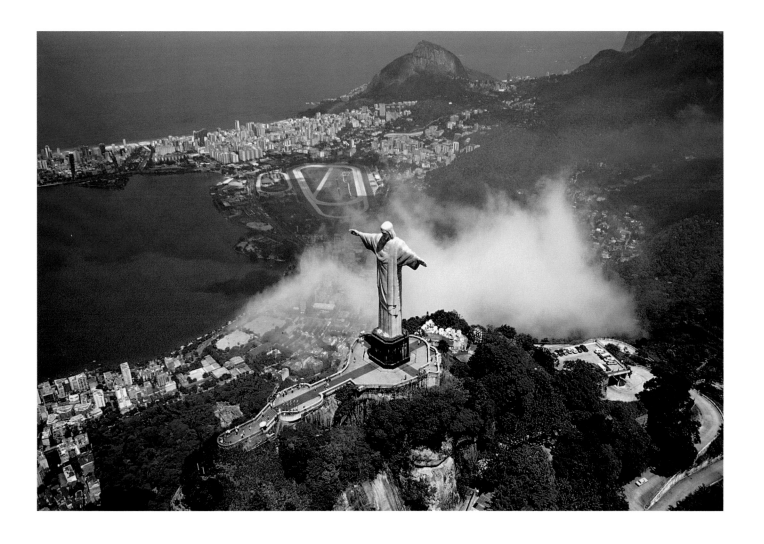

Mayan Ruins – Chichen Itza, Mexico

A wonderful three-hour drive from Cancun took us through sleepy Mexican villages. Arriving at Chichen Itza, we saw marvelous ruins from the Mayan era.

The statues and monuments are in good condition, allowing a visitor to explore a time when Mayan Indians, with an advanced culture, ruled the area. Climbing the main monument, we could see ruins for miles.

I have visited these ruins on four separate trips and I am still amazed at the advanced stages of civilization. The children I stood with at the ruins told me stories passed down from generation to generation. Life goes slowly on...

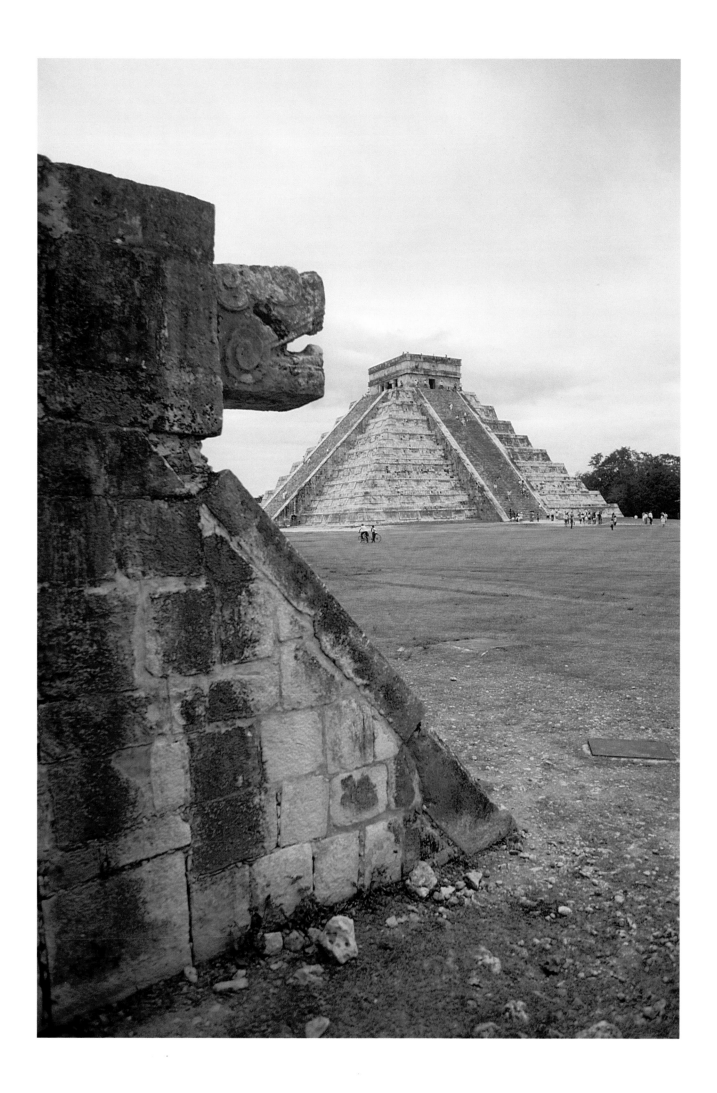

Colosseum – Rome, Italy

Romans rush by the Colosseum, and so many ruins in this eternal city, and hardly notice the grandeur. Centuries ago was a time when Rome ruled the world... this beauty is never lost on the visitor.

One of the joys of Rome is watching the local people. They drive recklessly in circles around the Colosseum, and all over the city. They rush, they honk and yell at each other. Congestion and smog are everywhere.

But, in the many Roman ruins, there is a quietness that retains respect. The stones hardly notice the confusion around – instead they remind the visitor of glories long ago.

When the Colosseum was filled to capacity, it rendered its share of noises. In these passageways, animals roamed under the floor, eventually coming on stage with gladiators to thrill the roaring crowds of over 70,000 spectators. It now sits quietly; but, if you listen carefully, you can hear the echoes of these great adventures.

I used filters on this image to create a photograph that feels like a painting. I can hear the faint echoes of the Colosseum in this quiet picture.

Milando, a photographer who shoots photos of tourists at the Colosseum, stood to the left of me with his friend (look to the end of this section to see my handsome friends). We talked a long time – in English, Italian, French, etc. – about the respect and power of the ruins in Italy. He is a man of wisdom and conviction. Talking with men, like Milando, again makes me realize how lucky I am to travel and meet people from other lands. How glad I am that my hobby and my profession are one.

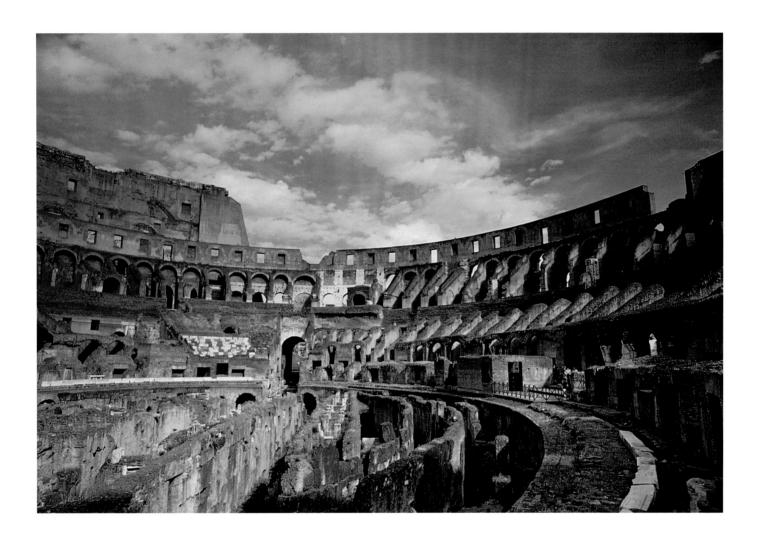

Little Mermaid – Copenhagen, Denmark

This is the fourth time I've seen the Mermaid... and it has never been sunny!

The reaction that first-time visitors always have is surprise at how small the mermaid is. Yes, we're bigger than she is – but nowhere near as noble.

She was inspired by one of Hans Christian Andersen's fairy tales about a mermaid who comes to life on land and falls in love. The story ends tragically, and the statue in the harbor almost appears to be searching for her love over the waters. The movie *Splash*, with Tom Hanks and Daryl Hannah, brings this fictitious story into today's world.

I was in Copenhagen in the late 1970's when students protested and painted the mermaid yellow. But she is back in good shape again, looking longingly out to sea.

Each time I've visited, someone is next to her sketching or painting. Her delicate features do inspire artists.

Someday perhaps I'll visit when the sun is shining. Although she won't look the same, or at least not as Danish.

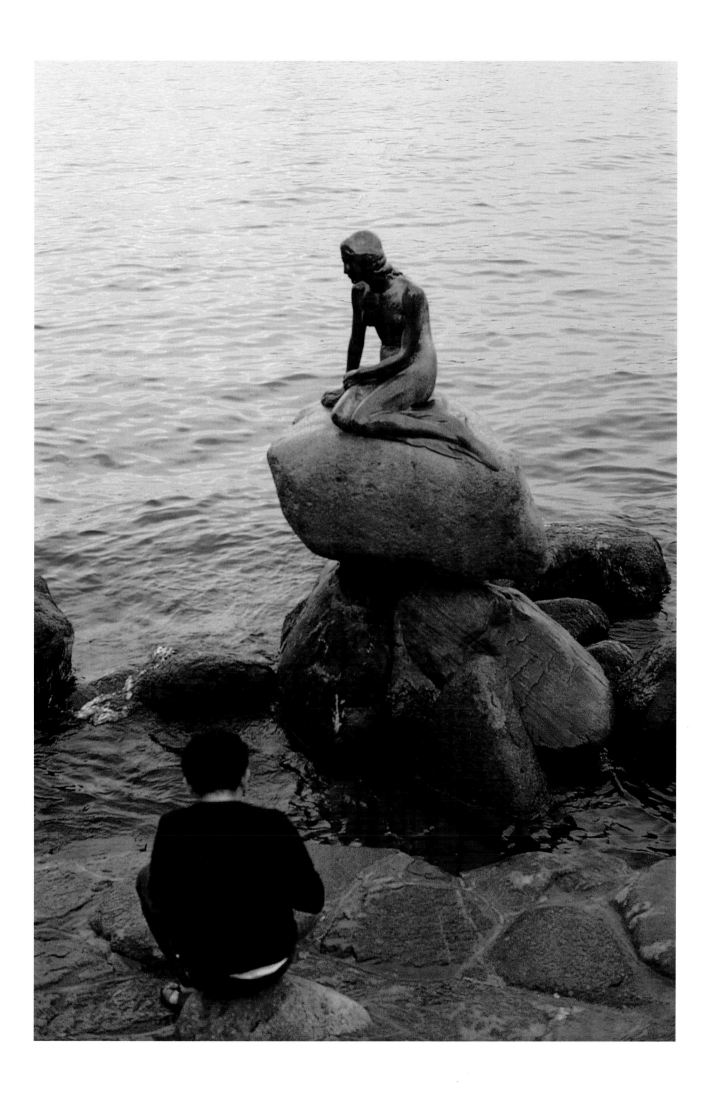

Skylon – Niagara Falls, Canada

Niagara Falls – once it was America's Honeymoon headquarters. Today it still brings many tourists to the Canadian side to look back into the USA and the powerful Falls.

Actually, most people only use the Skylon to get up to look across at the Falls. But, somehow, I still really like the Skylon for its singular beauty. I remember years ago my father bringing us here. He teased about the steep price to ride the elevator as we rode and said, "Boy, they could charge *anything* to come down!" Probably not a great joke to you, but I still chuckle and think of him along with the Skylon.

This is, indeed, one place where Canada is much better than the USA. New York's side has little to offer, while the Canadian side never runs out of energy and things to do.

Roy Puchelwartz stood with me at the Skylon for the photo in the back section. He is a minister and quite an interesting fellow. He also enjoys looking at the Skylon for itself, not only as an extension of the Falls. So he was glad to share space in the book.

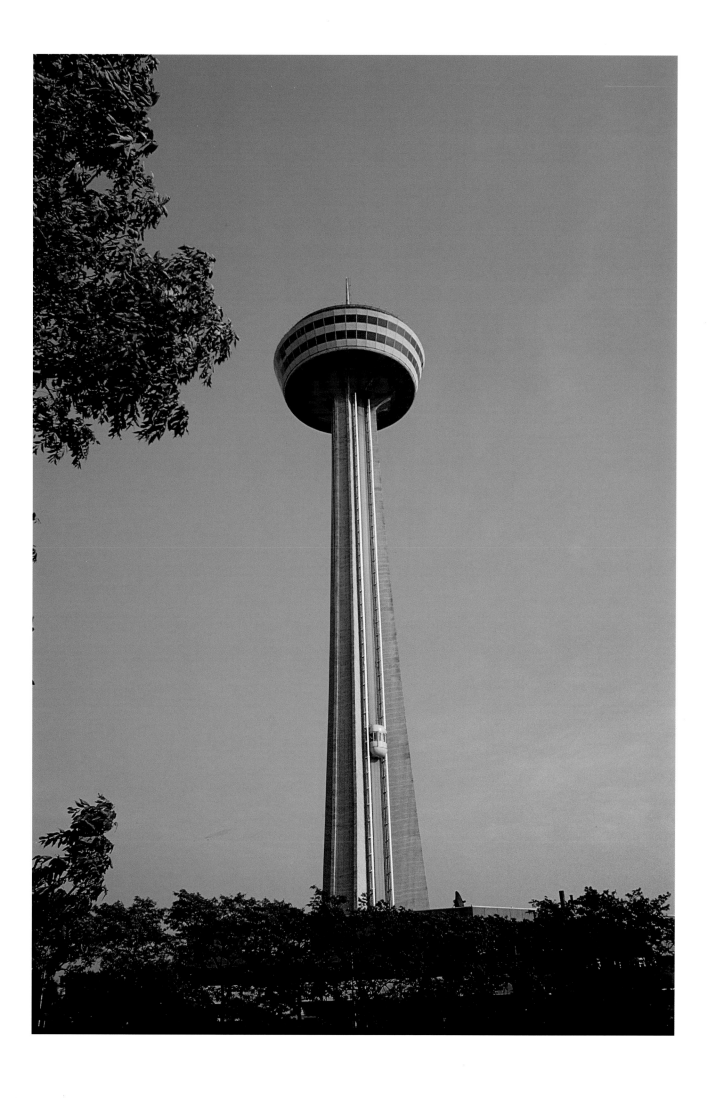

Opera House – Sydney, Australia

The Opera House sits proudly in one of the most spectacular harbors in the world. Its many shells are unlike any building in the world. And, once inside, the sounds of music are so clear and majestic.

This was my second visit to Australia, and both times I felt so very much at home. Even though it is halfway around the world from the USA, the comfort level is very grand. The people Down-Under are so warm and friendly. If I were just starting my career, I feel this might be one country to which I would relocate. Far from home, but very comfortable indeed.

Ferries circle the Opera House all day, crossing the beautiful bay. On this trip, I heard a concert and marveled at the sounds formed in these peaks.

The Olympics will be in Sydney in the year 2000; I will be back to share this with some great Australian friends.

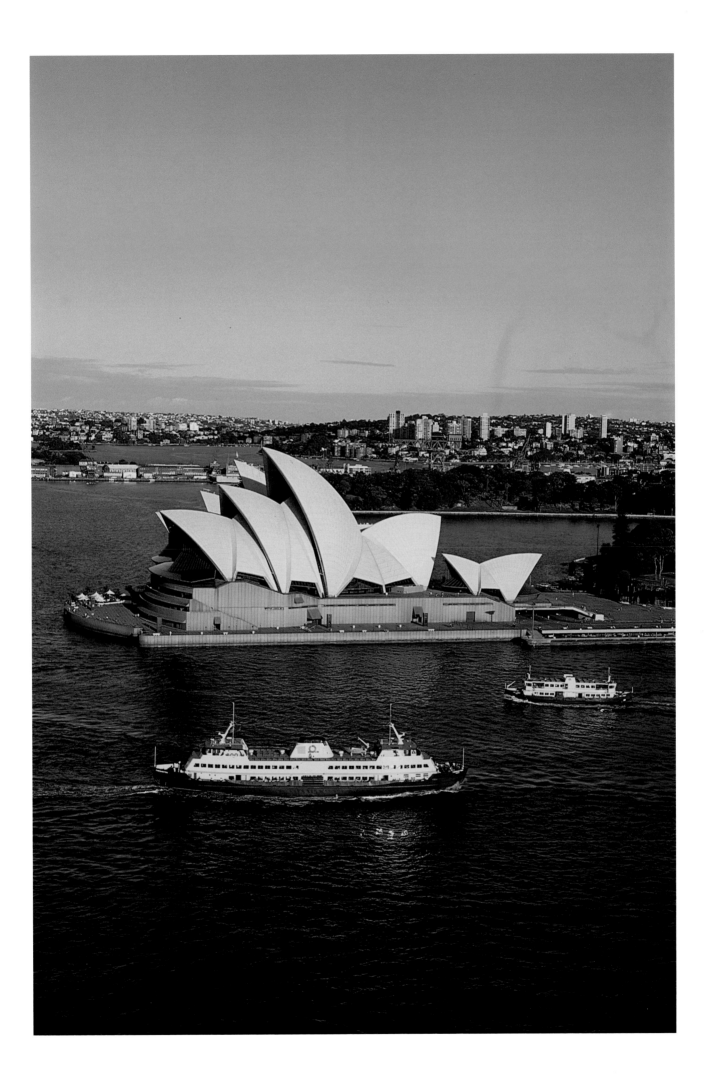

Arc de Triumphe – Paris, France

Everyone has a favorite photograph – this is probably the most special in my life. It's a little grainy, adding to the Impressionism that is so characteristic in French art.

We all would like to think our photography is "skill", but much of this shot I attribute to plain luck. That humbling fact is further reinforced by the fact that I have attempted to shoot a better shot of the Champs Elysees probably on six or seven other visits, including the World Tour, and never liked the results as well. In this image, everything came together photographically... the cab driver and cab being stationary and everything else moving gives a feeling of the energy of Paris.

This photo has also been one of my most lucrative. It became a limited-edition poster which has done really well, and the image has sold many times for ads, travel brochures, and magazine usages. In fact, a lady bought the poster in a New York gallery and "named" it... she told the gallery owner she wanted "Paris at 100 Miles Per Hour".

This is one of two shots in this presentation where I used photos taken before the tour of the monuments. It wasn't planned that way, but as I stated, luck plays a role in photography.

Paris always draws me back to shoot. Sure, it is expensive and, yes, the Parisians tend to be rude to everyone who isn't French. They seem to arrogantly know they have one of the greatest cities in the world, and you will enjoy it in spite of their attitude. And I always do.

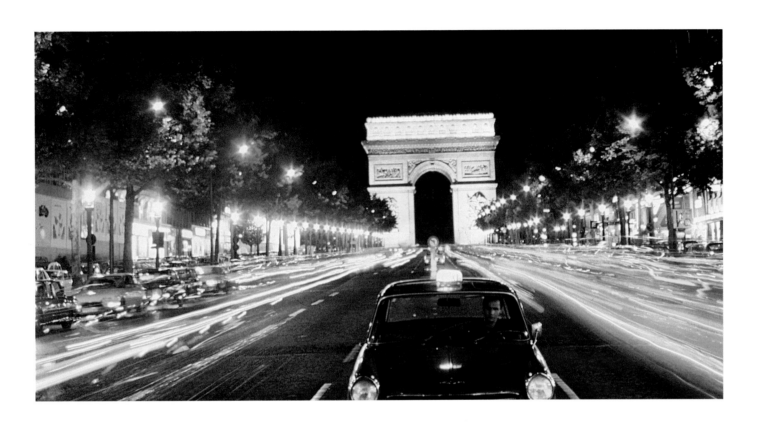

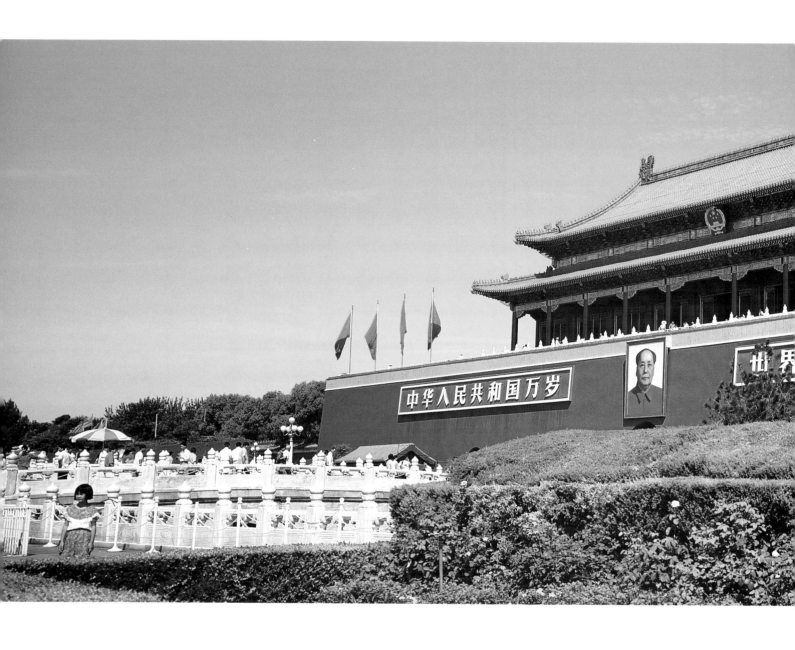

Forbidden City – Beijing, China

Beijing has been closed for so long to the West. China is the Big Bear, busting at the seams with its overpopulation and mammoth internal problems. Yet its sheer numbers make it a major force in the world.

Mao Tse-Tung, whose portrait is enshrined over the entrance, preached to the masses about political reform and opening doors to the West. This Forbidden City entrance is indeed quite impressive.

People from all over China now come to the entrance and wander into the once Forbidden City. The families come to have their photo taken with the portrait of Mao. It reminds me of Lenin's Tomb in Red Square, Moscow; there is that sense of reverence.

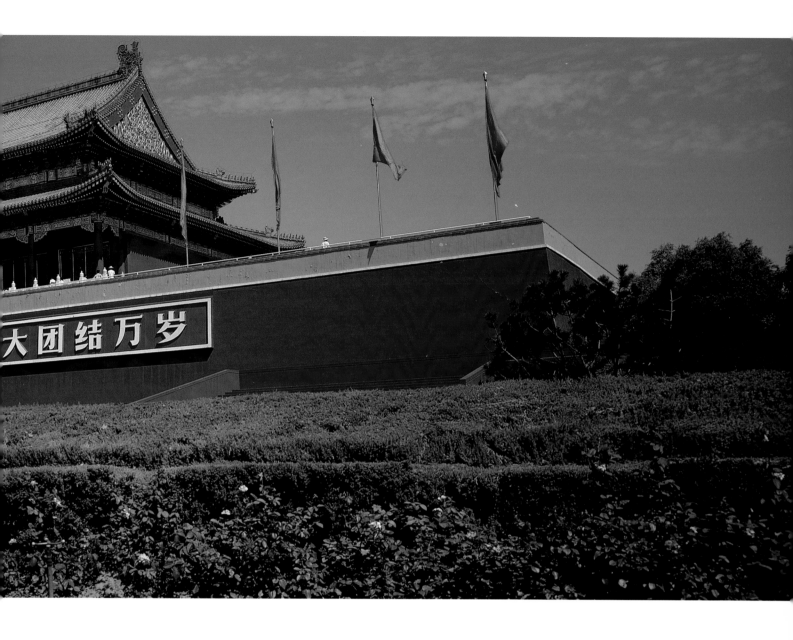

The entire world watched students protest against tanks only several feet behind where I stood to take this panoramic image at Tiananmen Square. Changes are rapidly coming, and will continue to happen, in China relations. Asia has the strength and numbers to be THE commerce area of the 21st century. Our leaders realize this as we attempt to restructure trade relations.

This entrance shall never lose its mystery and beauty. The bright colors and importance of this monument will be more appreciated by the West than ever, as China continues to open to the world.

Michelangelo's "David" – Florence, Italy

For centuries this wonderful city has been the center of the creative arts for the universe. As Vienna symbolizes music in the streets, Florence represents man's quest for the arts.

In this mecca of magnificent art, David epitomizes the masterpiece of sculpture. He stands alone in a wonderful museum, and has beckoned art lovers for hundreds of years to witness perfection. The dome lighting from above serves as a God-like radiance.

I display him here in Black & White – better showing the textures, tones, and reverence for which Michelangelo is so well known. If you only view one sculpture on earth, make it David.

In the Paris Louvre there is so much to see that people rush past the masterpieces to see it all. However, David is displayed in such a manner that you can stop and observe. And listen...

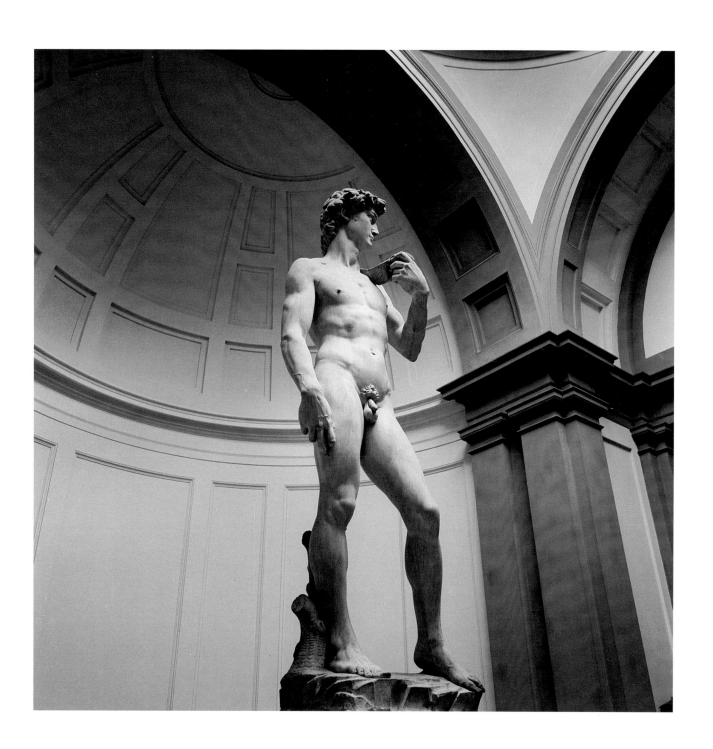

St. Basil's Cathedral – Moscow, Russia

I am not overwhelmed by many buildings, but St. Basil's in Red Square stops and shakes me! It dominates one's vision with beauty and power.

I have visited Russia twice. During the era when I grew up in the United States, Red Square meant the Enemy – May Day, missiles, power. I will never forget the first time I walked up from the subway into the cobblestoned square. My heart was rushing at the disbelief of actually being there. (I even shot a photo of my feet on the cobblestones.)

On this World Tour visit, I was still overwhelmed by the sight, despite all the massive changes in Russia. This trip I witnessed religious services in the square and even protests to return to Stalin Communism days – two events that never would have happened on my last visit in the Seventies.

I have many fears for the Russian people. Economically their system is in total disarray. Will they hold out long enough for reform to succeed, or will they slide back into "safe" Communism with another ruthless leader? So many people I talked to want to return to Communism, where they know what to expect. One of my fears is that some crazy leader will promise them a better life (another Hitler??) and gain control of their massive nuclear power. They seem ready to follow, and that scares me.

Yet, with all the turmoil and change, St. Basil's still stands – a monument of another lifetime. Ivan the Terrible had this church constructed for his own worship in the 15th century, and then had his architects blinded so they could never build another (he earned his nickname!). He had no idea of how the beauty of this church would touch millions over the years. As it touches me.

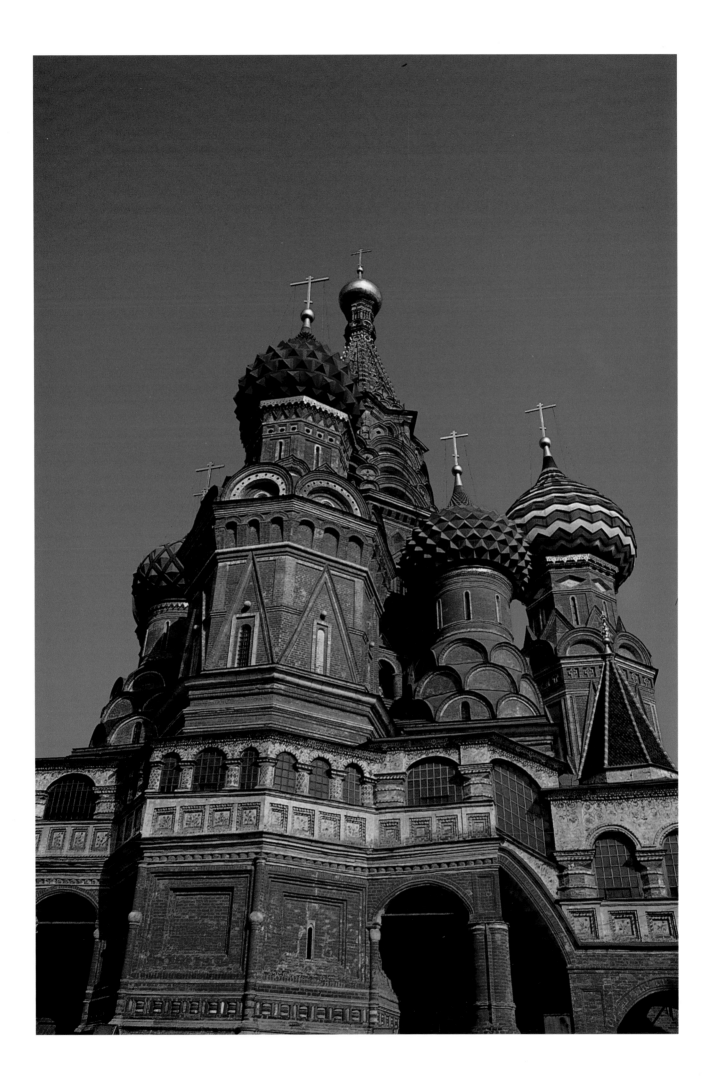

Taj Mahal – Agra, India

There is no country on earth with all the diversity of India. You can witness the most extreme wealth and poverty almost in the same view.

The Taj Mahal has been called the most beautiful structure in the world. I visited it several times and marveled as the first light of morning caused the pink glow on the Taj. During the day, the colors of the building change as the sun hits these marble stones at different angles. This tomb was built to show a king's love for his wife in 1630... did he ever imagine it would be so adored over the planet?

Driving the crazy Mathura Highway from New Delhi to Agra is the scariest and most unique trip on earth. Not for the fainthearted, there are several fatal accidents each day as cars, trucks, rickshaws, cows, camels, and bikes all share the small, rough lanes at reckless speeds. It is impossible to describe in words... you just breathe a sigh of relief when you arrive and pledge never to do it again.

I shot this through an arched doorway to have a unique view of this often photographed masterpiece. It created a different feeling for the image.

The sights I witnessed in India – the most extreme poverty imaginable – will stay with me forever. I think of images in India often. How can 800 million people ever live in that small country? They do, literally, on top of each other.

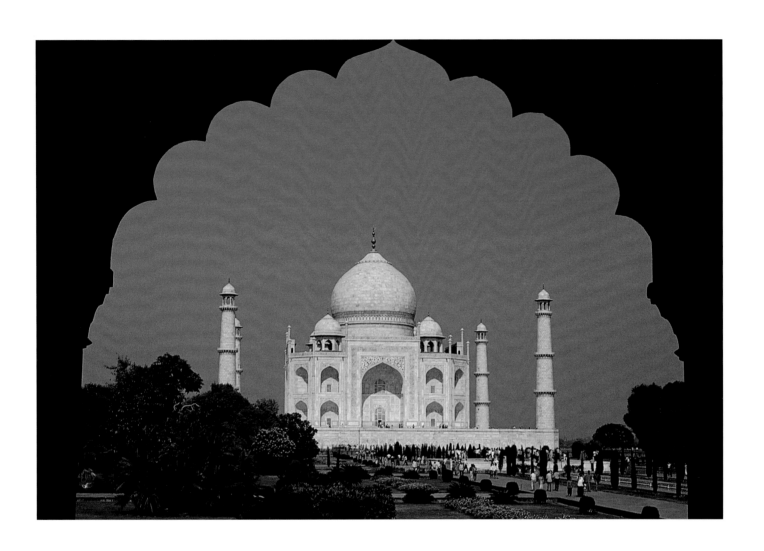

Eiffel Tower – Paris, France

Did you know that the Eiffel Tower was built in 1889 only for the World's Fair and the French people hated it? The Mayor of Paris hated it so much that he had lunch every day under it. When asked why, he replied, "It's the only place in the city where I don't see the damn thing!"

Actually, they wanted it torn down immediately afterwards, and it almost was. Thank goodness cooler heads prevailed. Now it stands as a monument not only for Paris, but for all of France.

I've photographed the Eiffel Tower on many visits, from every possible angle – night and day. But this night photo, taken on my World Tour, is my favorite view now. Most people don't appreciate the loneliness and fatigue inherent in a photographer's life, striving to capture on film images for others to witness. I shot through these fountains on a wet, freezing night, soaked from the wind blowing the fountain spray back at my camera. Seeing happy couples walk by arm-in-arm in this City of Romance... me, cold and alone, with only a tripod.

I have seen photos of the Eiffel Tower, taken from directly behind the fountain from the museum high above, but I now know why this shot through the fountains is so very rare. You get very wet!

It makes me re-evaluate my love for photography! Then chromes arrive from the lab and the discomforts are forgotten... until the next climb up a mountain with heavy equipment on my back. I always really only remember the good feelings.

I visit Paris often and sell much of my work there in their magazines. Everyone asks me about the Paris rudeness. The best quote I have heard regarding Parisian's attitude is:

"If Paris didn't exist, the world would sorely miss it.... if the rest of the world didn't exist, Paris wouldn't notice!"

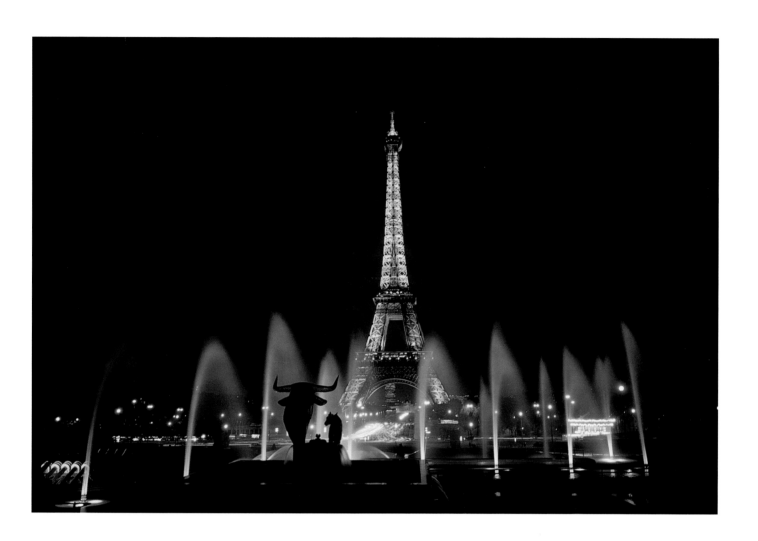

Stonehenge – Salisbury, England

In the middle of farming fields, two hours by train from London just outside of Salisbury, is one of man's strangest sights – Stonehenge.

No one is really sure who built this odd array of rocks, or even why it was built. Probably it was some ancient type of sun clock.

One thing that's for sure is that it will be raining. In this part of England, that is a given.

As I photographed this monument to the Gods, I knew I would superimpose one of my sun images on it to create an image of Stonehenge somewhat "surrealistic". I felt this would be a fitting way to represent this imposing sight.

The English chaps, that I took the photo in the back section with, drove up on a motorcycle with all the riding gear. They didn't seem to notice the rain, so why should I?

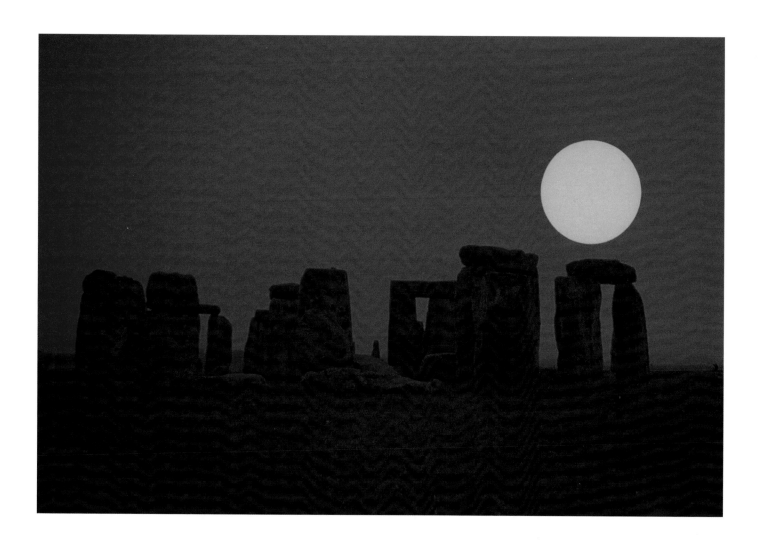

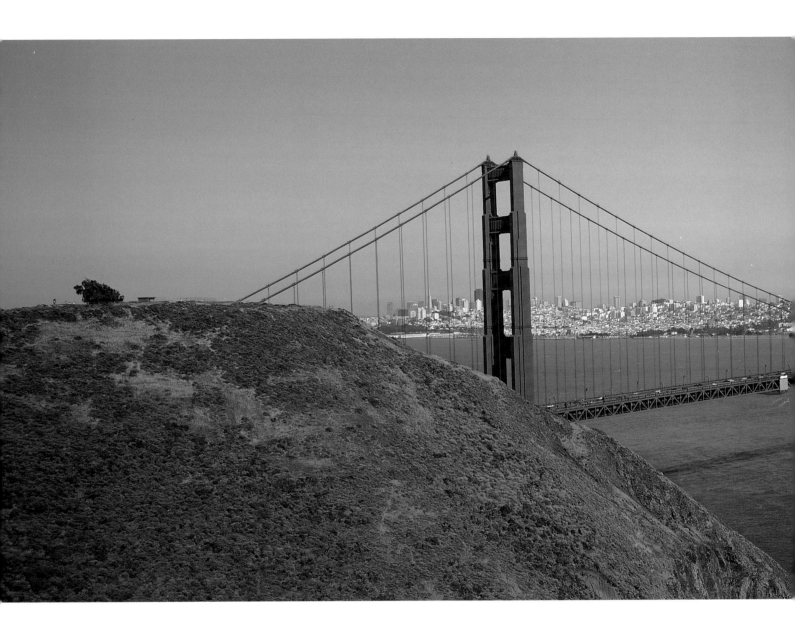

Golden Gate Bridge – San Francisco, California

The highest bridge in the world and definitely the most photographed. It's the symbol of the City by the Bay to people all over the world.

Most times in San Francisco the fog prevents viewing the entire bridge. Sometimes only the very top shows through the clouds.

On this clear and windy day I had the full sun and was able to make a panoramic photo of the bridge. Within one hour, however, the bridge had disappeared from sight as the fog and cold moved in.

People in San Francisco love their Golden Gate. They walk, jog, and bicycle

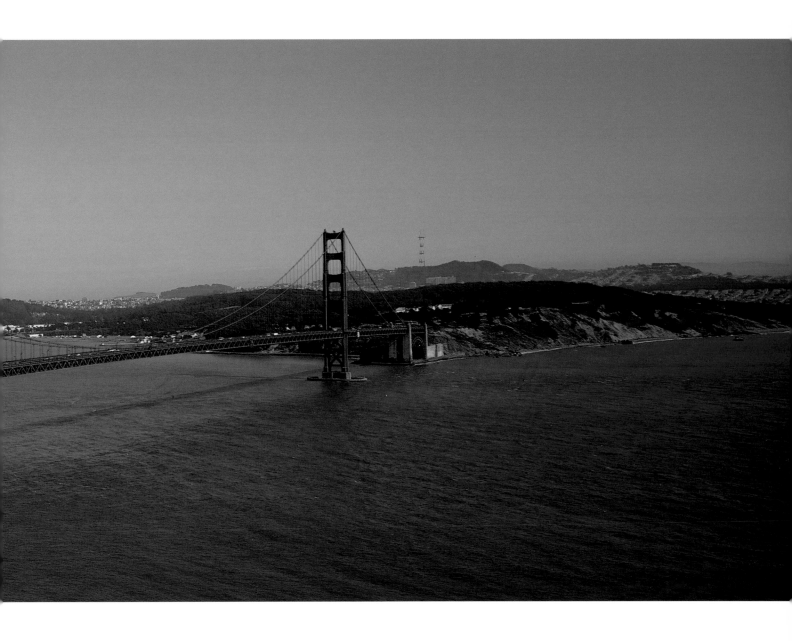

across it with no particular place to go. Most cities tend to ignore their wonderful sights – most New Yorkers have never set foot on Ellis Island at the Statue of Liberty, for example. But the Golden Gate is different; it is appreciated and used by the locals.

The Indian man with me, at the back of this section, is finishing his medical school in San Francisco. We were almost blown over the edge of the mountain in the gusts of wind as we held the poster. I had fun – I wonder if he did?

Wailing Wall – Jerusalem, Israel

The beautiful country of Israel is a refuge for Jewish people from all over the world. Yet it also never feels safe... it is surrounded by guns, fighting, hatred. On one of my days here, I came upon a crowd formed around a boy who had been killed by snipers in the West Bank. Will this hatred ever end, even with a peace treaty? Can we legislate the end of hatred and mistrust?

The Wailing Wall is a holy place. This is the only remaining segment from the original walls of the Temple of Solomon, and the Jewish faith is ever present here. Only men may come to this section of the wall, and the head must be covered. Everywhere small prayer requests are folded and slipped into the cracks.

Actually, when I came home from this trip I read in the paper that, unfortunately, high technology has caught up to the Wall. You can now FAX a prayer request from the USA to be placed into the cracks. Come on... is this really necessary?

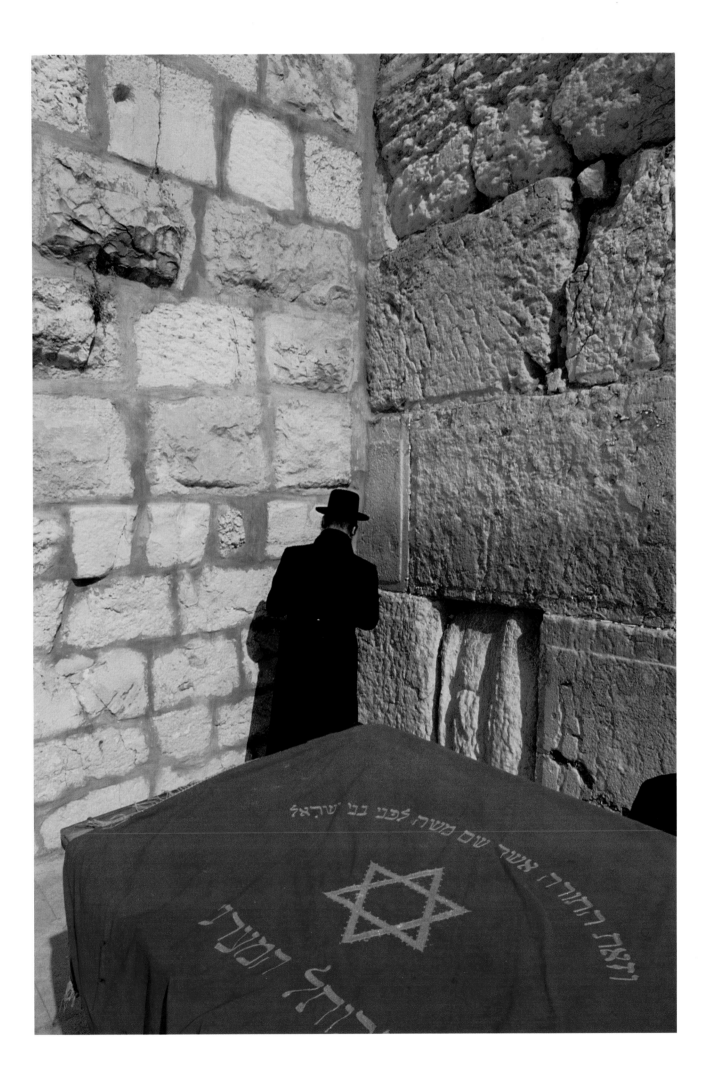

Gateway Arch – St. Louis, Missouri

This arch is to St. Louis what the Eiffel Tower is to Paris. It symbolizes the strength and importance of the Midwest and its people.

The Arch truly is the Gateway To The West. You can see the arch from all over the area. St. Louis has turned the base of the arch into a park on the famous Mississippi River, a place of fun activities for the entire family to enjoy. This park also has witnessed the power of the Mississippi River in the awesome floods... this mighty river gives and it takes.

St. Louis actually was the first stop on my two-year World Tour, so it really was my Gateway as well. I have photographed the Arch several times, and have yet to find a "bad" angle. This time I rested in the flowers to look up for an unusual perspective.

Sister Patricia stood with me to hold the poster in front of the arch. I had a long and interesting talk with her and realized, as I started on this trip around the world, that meeting people for the poster shots would help me reach out and meet unique characters along the way.

I have heard that a TWA pilot, on his last flight before retiring, took his jet through the Gateway Arch. I wish I'd seen that...

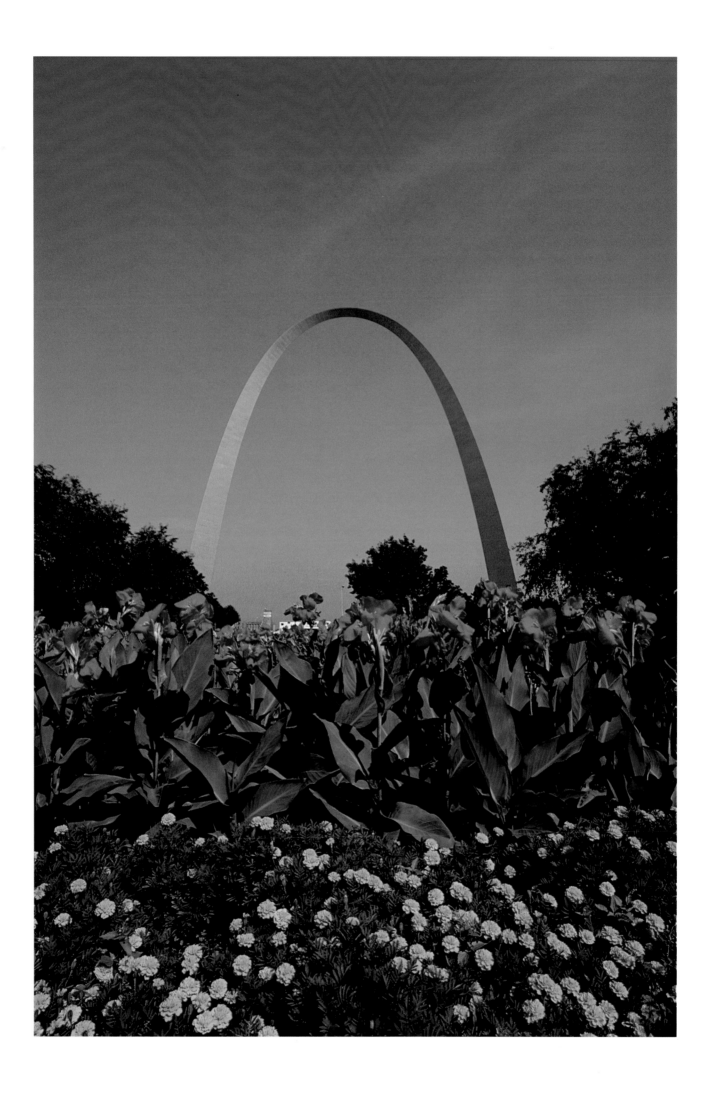

Leaning Tower of Pisa – Pisa, Italy

Where would this tower be in importance of the world if it were constructed more solidly? Are we celebrating incompetence?

Yes. Because this building is slowly sinking, it is one of the most famous buildings of the world. The people who make their money on tourism in Pisa must be thankful for poor engineering!

People from all over the world – from architects to laymen – have sent drawings and plans to the council of Pisa with suggestions on how to reconstruct and "straighten" the Leaning Tower. I'm not really sure that the council wants to correct the flaw!

On past visits I went inside the tower. Recently, however, tourists have been forbidden inside. But this doesn't forbid us from leaning in front, or pretending to hold up the building. I met an Italian brother & sister to lean with me for the poster shot at the end of this section. It sure wasn't an original idea.

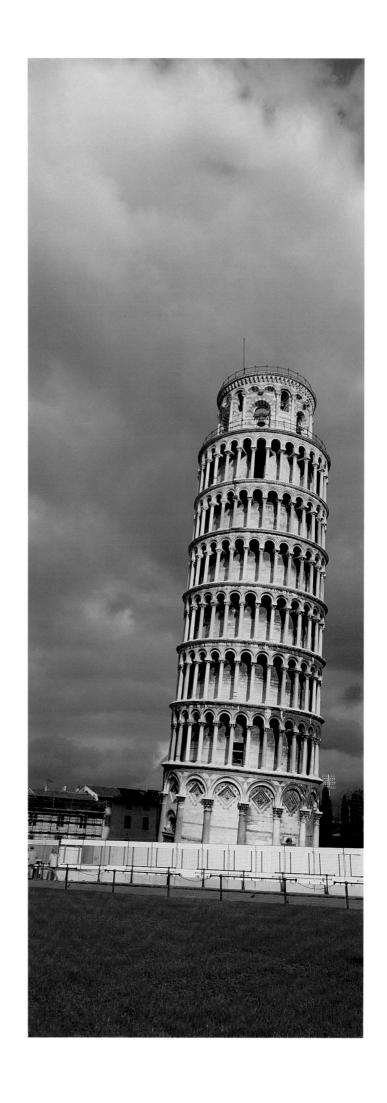

Great Buddha – Kamakura, Japan

From Tokyo – a giant, frantic city full of congestion – a short train ride to the country brings you to Kamakura. This small relaxed village is home to the largest buddha in the world, The Great Buddha.

I've been here twice and marveled at its quiet strength. The copper has slowly turned green over the years, but the reverence of the Buddhist religion has remained unchanged over the centuries. I'm glad I've discovered this quiet part of Japan.

The Japanese man I was with is Ko Kurokawa. He was so proud to share a portrait in the back of this section. He lives now in Michigan as a Human Factors Product Engineer with General Motors, but he was back in Tokyo to visit his parents. He had never visited the Buddha, so I invited him to accompany me. And on the way I showed him how to play gin. Soon he was winning...

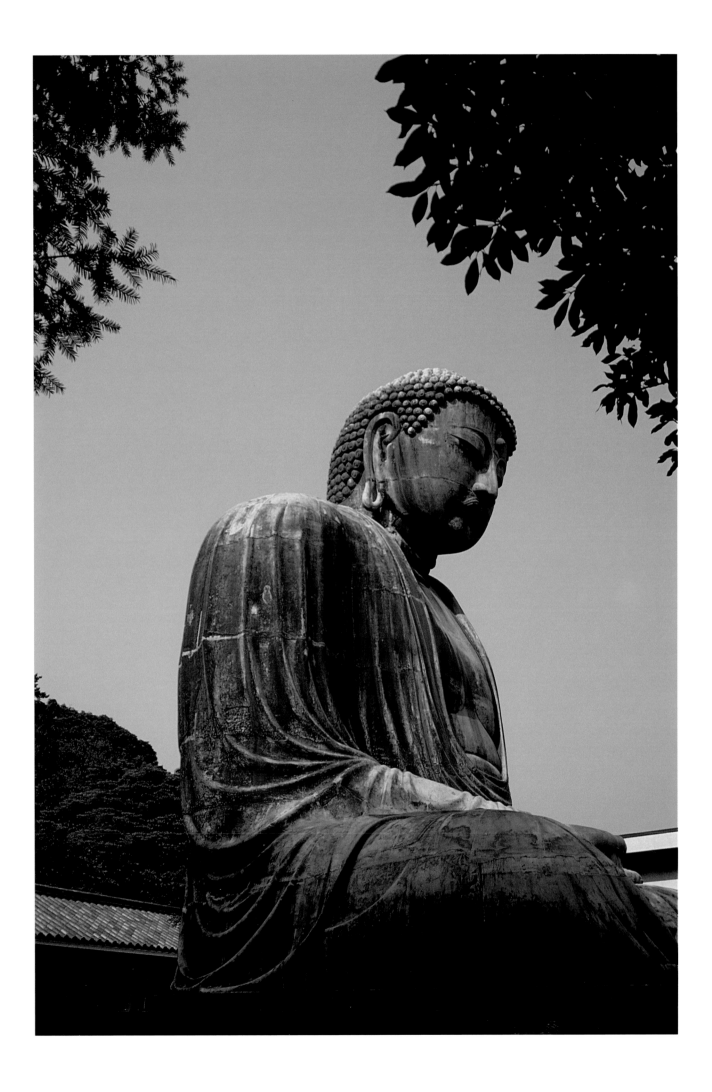

Space Needle – Seattle, Washington

On a clear day Mt. Rainier is beautifully visible in the background. Puget Sound hugs the coast and ships stream into the Pacific Northwest. The Space Needle sits on top of this great, green city of Seattle.

It's a clean and energetic city. The people have come to accept the many days of rain and drizzle. Most of my visits to Seattle have included rain. But on the days the sun breaks through, you will not find a bluer sky anywhere. The abundant rain makes everything colorful and clean, a wonderful place to live.

I found a small park with red tubes for children near the tower that I thought would be an interesting foreground to this colorful photograph. As I photographed the Space Needle from this area, I started a conversation with a very nice set of grandparents. The grandson proudly told me right away his name was Michael, named after his grandfather.

We had a nice talk, so I wanted a photo with the two Michaels. I gave grandmother my camera and we three guys stood on a picnic table so she could get low to shoot us with the monument. I asked her if she could see us and the monument, and she said yes. Snap... the resulting photo had the ground, table, us and only the bottom half of the needle. Look at the back of this section to see her mistake. Oh well, from that moment on, for my poster shot, I put the camera on a tripod and framed the photo first.

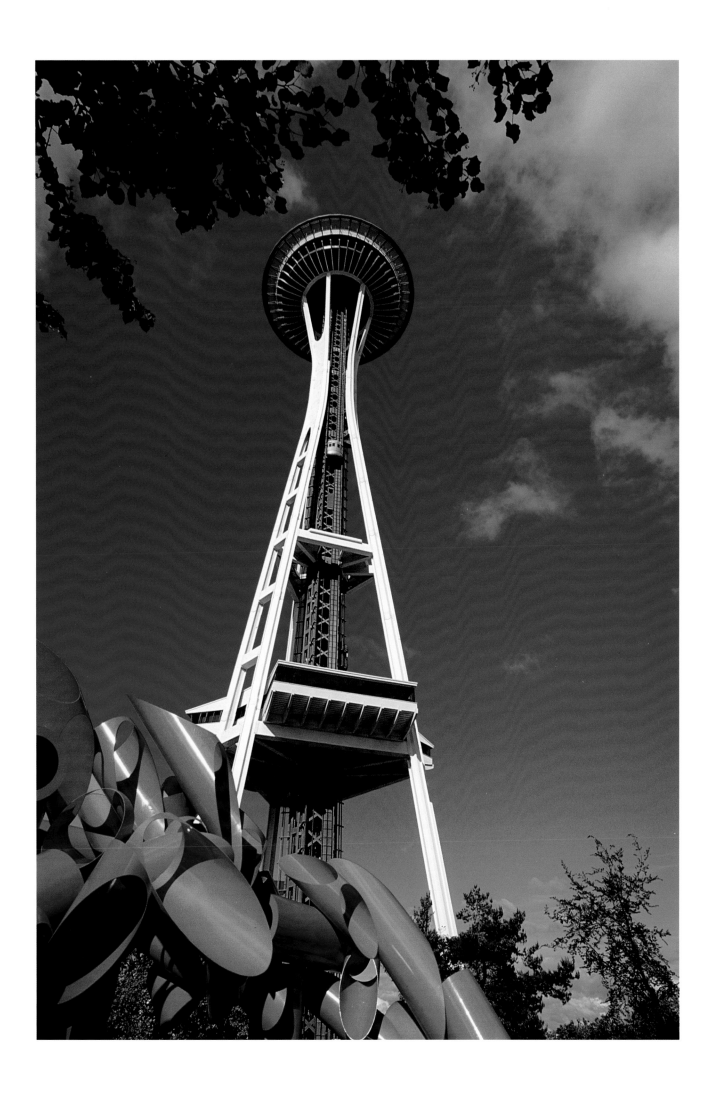

Berlin Wall – East Berlin, Germany

This wall has a history of horror unlike any in this world. It symbolized terror and oppression. It represented all that was bad about Communism.

I have visited the Berlin Wall on three occasions, years apart, and they all have been very different. The first visit the Wall struck fear in the world, and in me. Several people were killed the week I was there. I was even shot at one day, but that's another story. All East Berliners had fear in their eyes. They had no hope that life would ever be better.

The Reunification of Germany found me at the Wall a second time. This was a joyous time as people chipped off pieces of the Wall with hammers. I also took a turn to capture pieces of history for all my relatives. I wrote a magazine story entitled *Welcome Back Berlin* on this visit, describing the joyful reunification.

My third visit was for the World Tour. Most of the Wall is gone now, with only several small sections neatly painted by artists remaining. It has lost all of its fear and gloom. The euphoria is also gone, replaced by the reality that Germany has years ahead of financial strain as the Eastern sector is rebuilt in both factories and lifestyle.

The Wall has been meaningful to me, covering the entire range of emotions. For this photograph I chose an image from the second visit, displaying a jubilant East German man happily destroying the barrier that had restrained him all of his life. The world applauded with him.

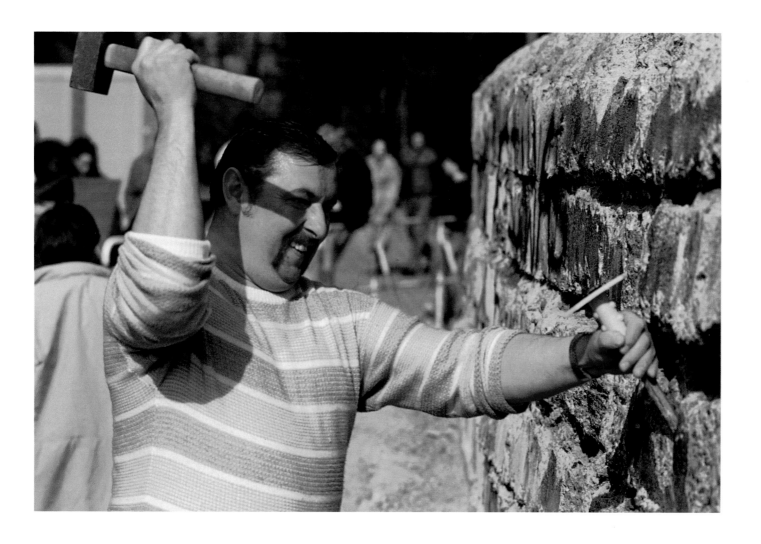

Tower Bridge – London, England

Most Americans mistakenly call this the London Bridge. British residents quietly chuckle at the mistake. England made quite a profit selling the real London Bridge (they were going to tear it down anyway) to the good ol' USA. It now sits in Arizona – quite a change in climate!

Actually, England often has a comical relationship with the USA. My favorite ad campaign in London was several years ago for British Airlines directed at Americans to come to England. It simply stated, "Come back, America... all is forgiven!"

The Tower Bridge resides near the Tower of London, where the Queen's famed crown jewels are stored. The bridge sits beautifully framing the famous river Thames and the Tower of London.

I have many daytime photos of the Tower Bridge, but I wanted a spectacular night shot. Only a photographer understands the lonely cold waiting at sunset for the perfect light. It really was cold this evening as I waited and waited, but I think I captured what I wanted. When we photographers look at our images, we forget the discomfort.

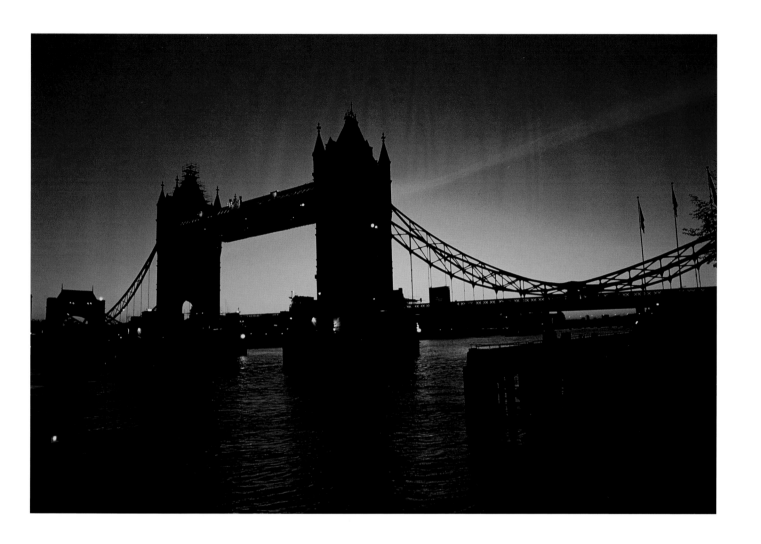

Washington Monument – Washington, D.C.

There are so many monuments and historical buildings in Washington. One of my problems for the World Tour was deciding which ones to photograph. The Capitol building is world-known, but many other capitol buildings are similar.

The Washington Monument was the final selection. Crowds gather each day to go up to the point for the best view of downtown Washington.

In 1986, I shot for Coca-Cola the *Hands Across America* line at the monument. On that May 25, the entire USA joined hands from coast to coast and it was a major event of our times. I rushed to photograph it after being in the hospital most of the day with a painful kidney stone. What a crazy day.

For this World Tour photo, I wanted to step back and bring the monument into its environment more. Most shots of the Washington Monument make it look so imposing – the giant tower going straight up in the air. I wanted the monument to glow, so I waited for the special light of the day, and captured it as part of its surroundings.

I always feel good being around this monument. I'm not sure I know why, nor do I really need to know why. It just feels right...

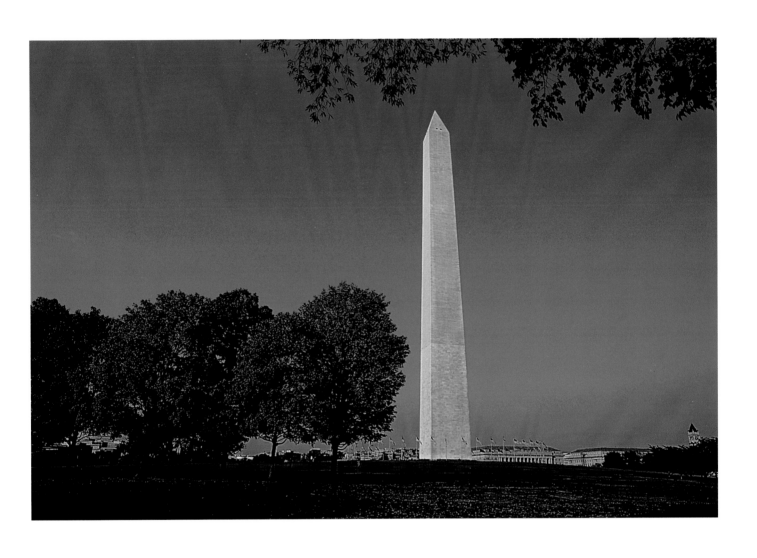

These very special people stood with me at each of the monuments of the world. What a splendid way to meet individuals from different countries and discuss various philosophies.

Some of these people I only spent several minutes with... some I spent days. I have received letters from a couple of them, and plan to keep writing.

I thank them again for sharing time with me on this wonderful World Tour adventure, and for the insights they shared. After these three pages of individual photographs, I enclose a copy of the same poster I carried around the earth... signed by each of these people in their own language.

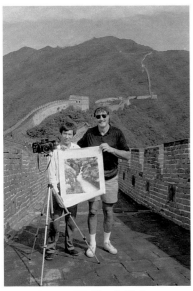

Great Wall of China
Mutiamya, China

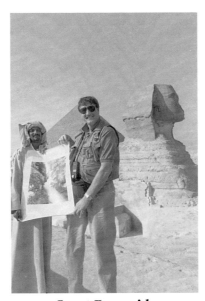

Great Pyramids
Giza, Egypt

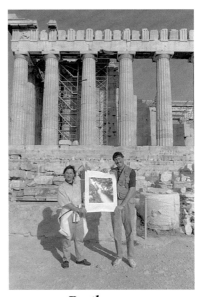

Parthenon
Athens, Greece

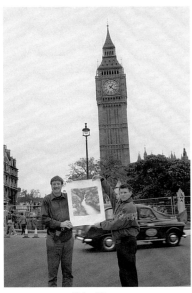

Big Ben
London, England

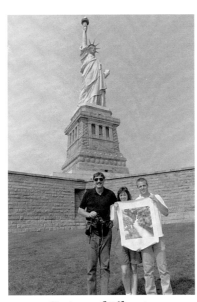

Statue of Liberty
New York

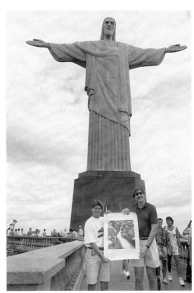

Corcovado Statue
Rio de Janeiro, Brazil

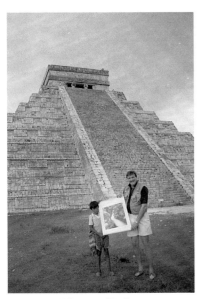

Mayan Ruins
Chichen Itza, Mexico

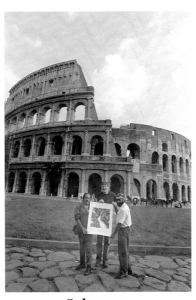

Colosseum
Rome, Italy

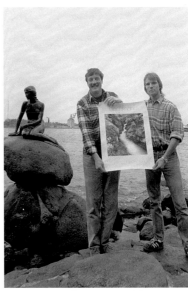

Little Mermaid
Copenhagen, Denmark

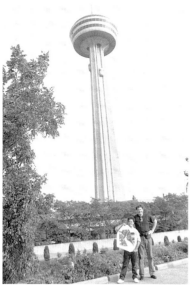

Skylon
Niagara Falls, Canada

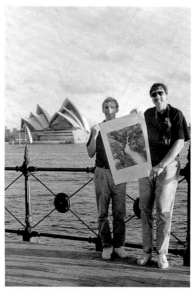

Opera House
Sydney, Australia

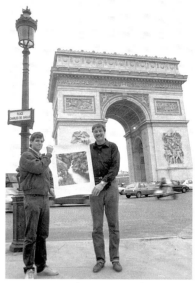

Arc de Triumphe
Paris, France

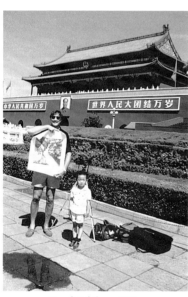

Forbidden City
Beijing, China

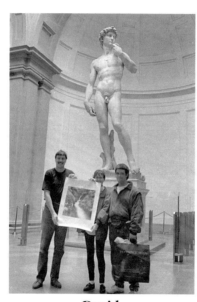

David
Florence, Italy

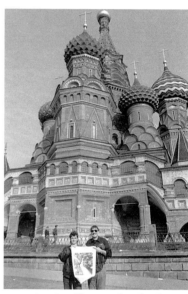

St. Basil's Cathedral
Moscow, Russia

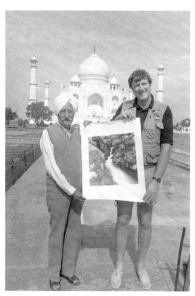

Taj Mahal
Agra, India

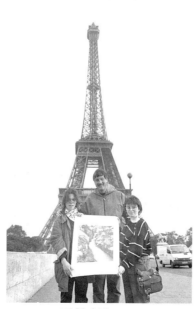

Eiffel Tower
Paris, France

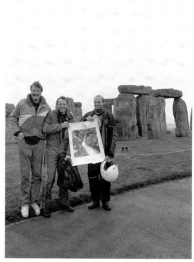

Stonehenge
Salisbury, England

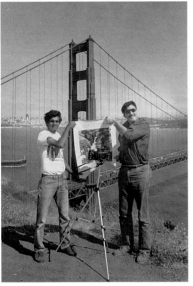

Golden Gate Bridge
San Francisco, California

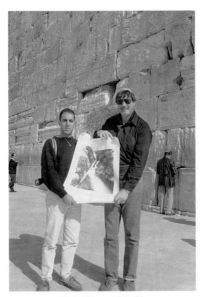

Wailing Wall
Jerusalem, Israel

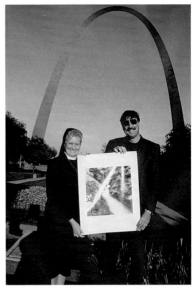

Gateway Arch
St. Louis, Missouri

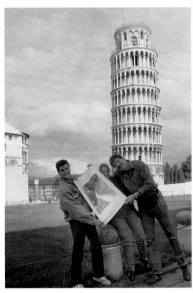

Leaning Tower of Pisa
Pisa, Italy

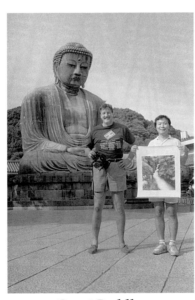

Great Buddha
Kamakura, Japan

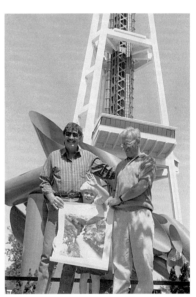

Space Needle
Seattle, Washington

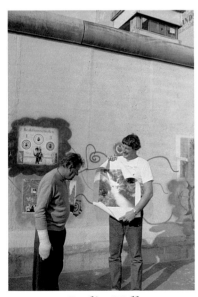

Berlin Wall
East Berlin, Germany

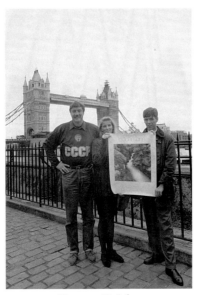

Tower Bridge
London, England

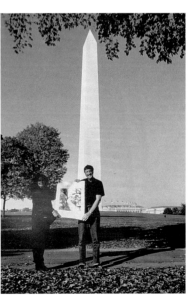

Washington Monument
Washington, D. C.

Introspective World Signed Poster

Here is a photo of my worn poster that traveled around the world with me on the tour of monuments. It was signed by each of the persons you have seen in the B&W photographs at the monuments, in his or her native language. It's interesting to look at the various signatures, whether they be in Russian, Hebrew, Chinese, Arabic, or Japanese.

Because of this "people touch" at all the world's monuments, I was able to approach people in different languages and lifestyles and, together, we overcame barriers and were just humans. I met some really fine people, some I will see again. It really forced me to reach out to people, when it was safer to not talk to anyone, and just shoot photographs. I'm glad I had that vehicle to allow me to communicate. It showed me again that the world is made of people like you and me... we speak differently, but we all have the same desires and needs. I proudly display this poster in my home. It traveled with me on all the planes and trains. It's rather beat-up, but so am I. And I'm glad we experienced all the ups and downs of this journey together.

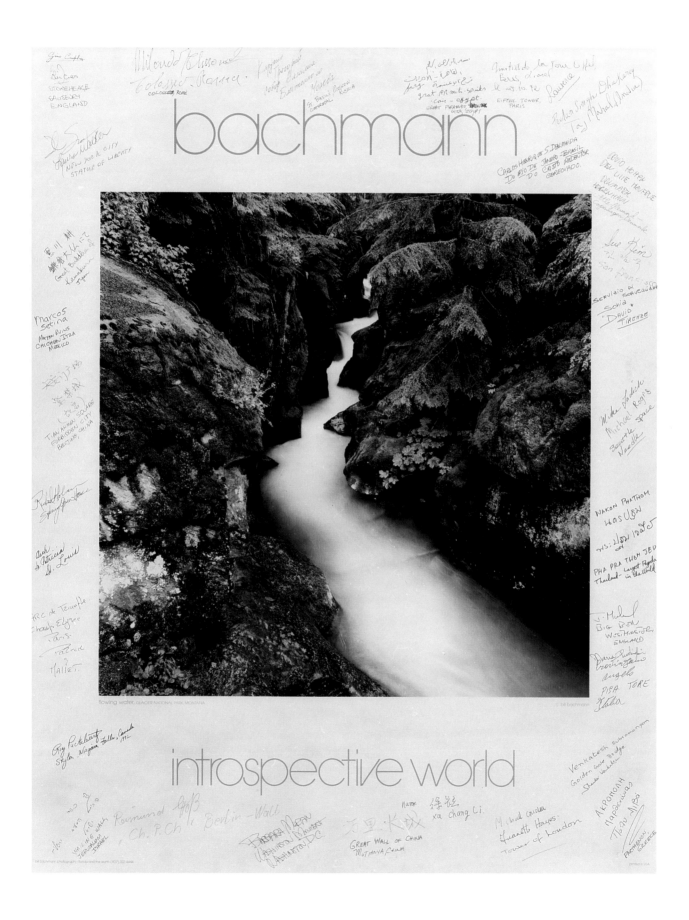

bachmann

introspective world

flowing water, GLACIER NATIONAL PARK, MONTANA

PEOPLE & PLACES

This second section has images that I have taken in many countries of the world. Traveling the world with a camera allows me greater freedom than I could ever have without one. It allows me to open my senses and "taste" what I see. It slows my travels down so that I can experience; it allows me to quietly "listen" to places.

All of the inconveniences of traveling, schedules, missed connections, bad weather, and the like are forgotten when I get to shoot pictures that I love. Travel photographers seem to create "blinders" over our eyes on all the bad that happens around us, as our tunnel vision searches for perfect images to put on film. Passion overtakes fear as we become "one" with the environment. *National Geographic* photographer, Win Parks, once sent a typical message to the magazine from location. "The water supply has been shut off, a strike has cancelled the post and phone companies, civil employees are striking and the mayor has resigned... We're making good headway in the coverage."

I never realized the grip photography would have on my senses when I started this profession. My mother tells me that I enthusiastically started taking pictures with a Brownie Hawkeye at age four... and I make my living today with that same excitement. I can think of no other profession for me, creating individual impressions with a little black box.

Photography has been a wonderful venture. I create advertising photography for many international ad campaigns and, when I have the time, I go off and create images that I love. These photographs that I do from my "heart" are more my interpretation of the world and are, therefore, more special to me.

"I DIDN'T CHOOSE TO BE A PHOTOGRAPHER... I HAD TO BE!!"

I read that somewhere - and I wish I could credit the author - but it is how I feel about my profession. There are many difficult parts of the professional photography career, but the amusing thing is that I only remember the good times.

Traveling the world, with or without big photo crews, shooting pictures brings a joy that is very difficult to describe. I only know I am thankful, indeed, to have a great hobby that turned into a great profession.

These are special images to me... a chance to slow down, savor the words, and "listen".

Bridge and Lilies – Bar Harbor, Maine

I saw this bridge near the picturesque town of Bar Harbor and remembered the famous Monet Impressionism painting. This little house, and curved bridge resting peacefully over the brook, is very close to a perfect scene.

I shot with infrared film to make it feel like Monet's painting.

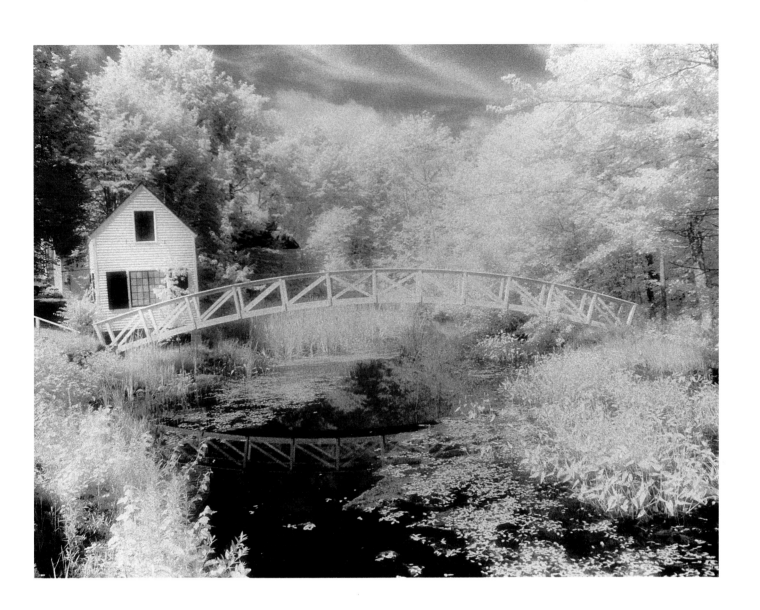

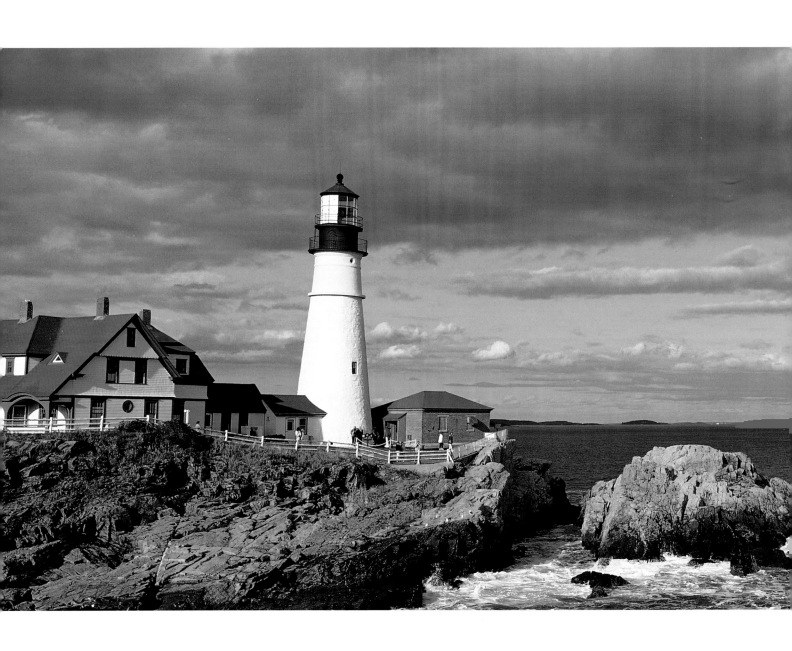

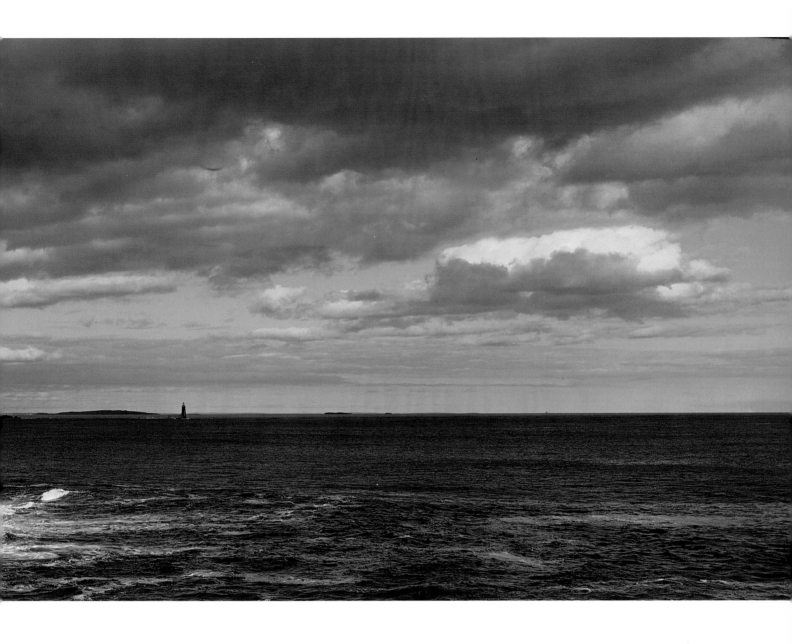

Portland Lighthouse – Portland, Maine

I have been here several times and I always leave feeling relaxed. The man who watches the boats in the harbor lives here in this house... what a relaxing yard he has!

I waited for the sky to get "interesting" and it didn't disappoint me. It started out real blue, and I saw a storm in the distance. Photography is often waiting, not pushing the shutter until the right moment. The threatening sky makes this image more dramatic.

I find this photo so relaxing in my own home - the perfect living room six-foot enlargement. I can hear the waves and smell the sea while I enjoy its peace.

Old Town – Prague, Republic of Czech

I feel this is the most beautiful city in Europe. During the war, most of Europe was bombed and the buildings were destroyed. Prague was spared the bombs, but during the Communist rule most of the city became dirty and depressing. Now that Eastern Europe is free, most of the cities are rebuilding. All Prague has to do is spray clean these wonderful buildings with their ornate facades along the rooftops. The unwritten rule now is, "When in Prague, look up!"

I climbed up a large, narrow clock tower to look down on the old town section and captured this graphic photograph of the square.

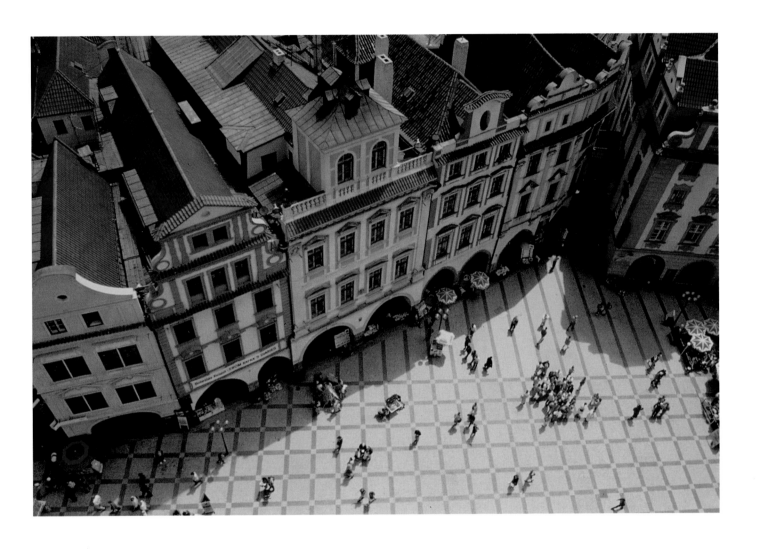

Hindu Woman – Taj Mahal, India

Such a colorful and pleasant woman framed by the famous Taj Mahal. I knew to ask her husband if I could take her photo (a custom you must respect in Hindu countries).

He was honored that I thought his wife was so beautiful and he agreed. I was just very lucky to meet such a grand smile.

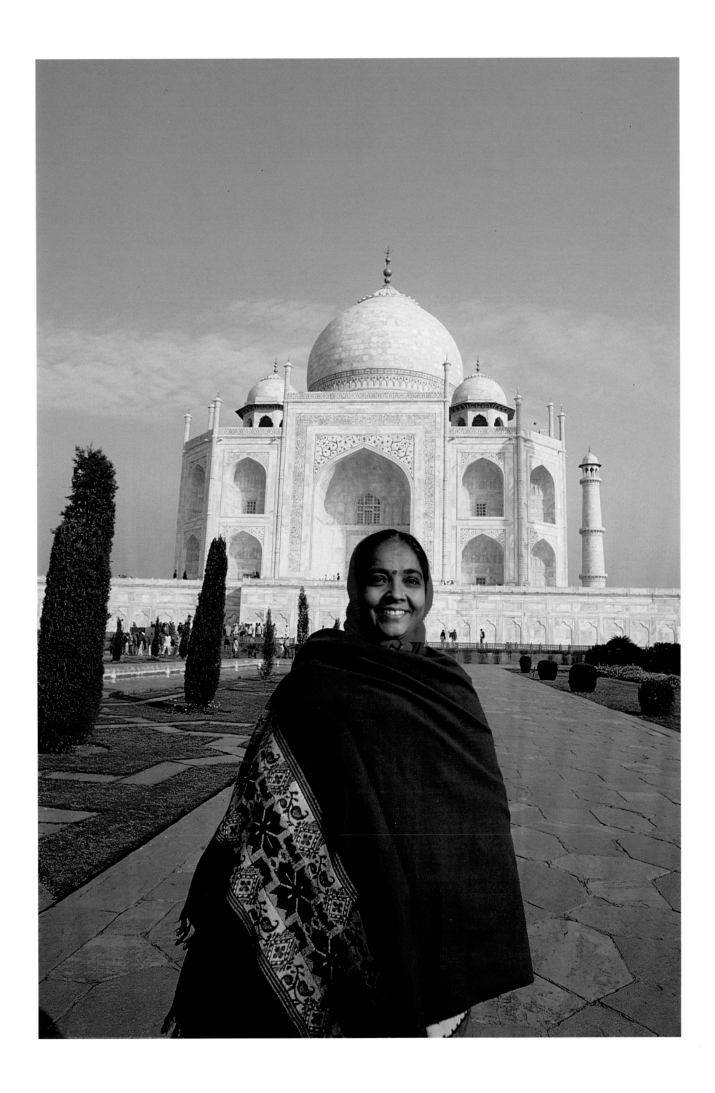

Maasai Tribe – Kenya, Africa

I have never had a better reception to shooting Polaroids than this tribe in the country outside of Kenya. The entire tribe came and shared laughter and surprise as their prints materialized in front of them.

Since Luke told them I had more film, I gave Polaroids to everyone in the community. So, halfway around the world in Africa, this tribe has pictures of themselves pinned to the walls of their mud shacks. It was so wonderful to share with them those moments of laughter.

This is the famous "jumping tribe" and I also have photos of this man jumping for the camera. Half of the photos have him still holding his prized Polaroid. I really had to work to convince him to put it down for my other photos. To see how a native loves a photo of himself, that he has never seen happen before, is a joy in itself!

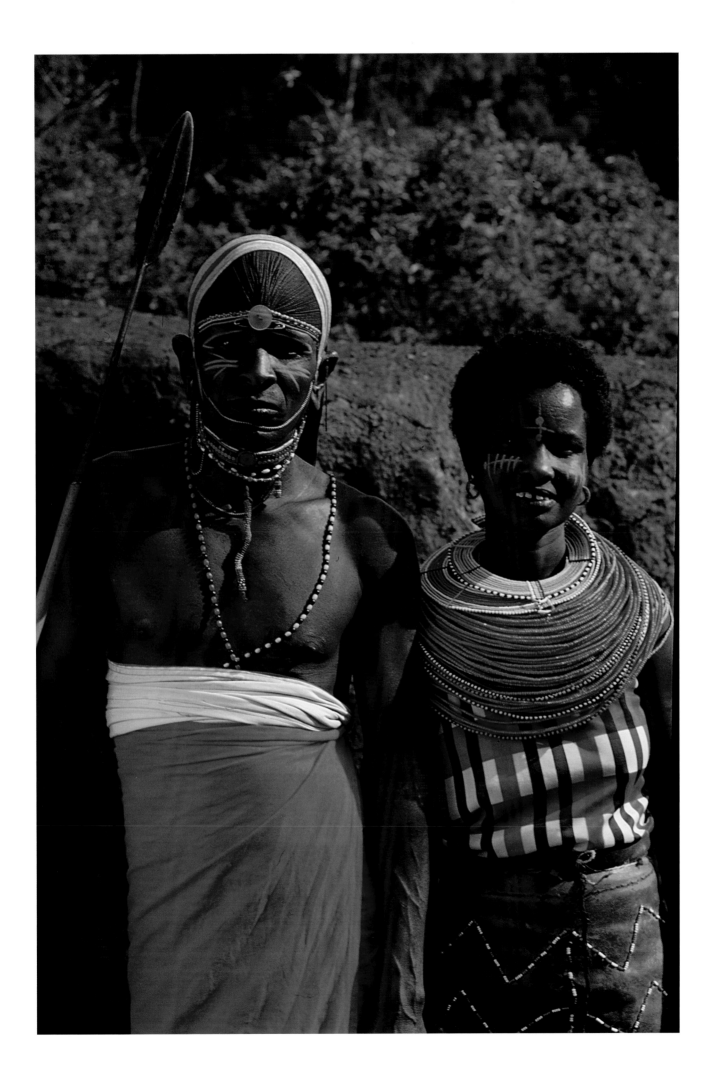

Parliament and Chain Bridge – Budapest, Hungary

Budapest is now shining for the world to see. For so many years it shared the Communist gloom, but now it is clean, inexpensive and ready for outsiders.

At night the entire Chain Bridge lights up and Budapest becomes one of the most beautiful European cities. Boats pass by on the historical Danube River in summer, and the city shows off its new-found freedom.

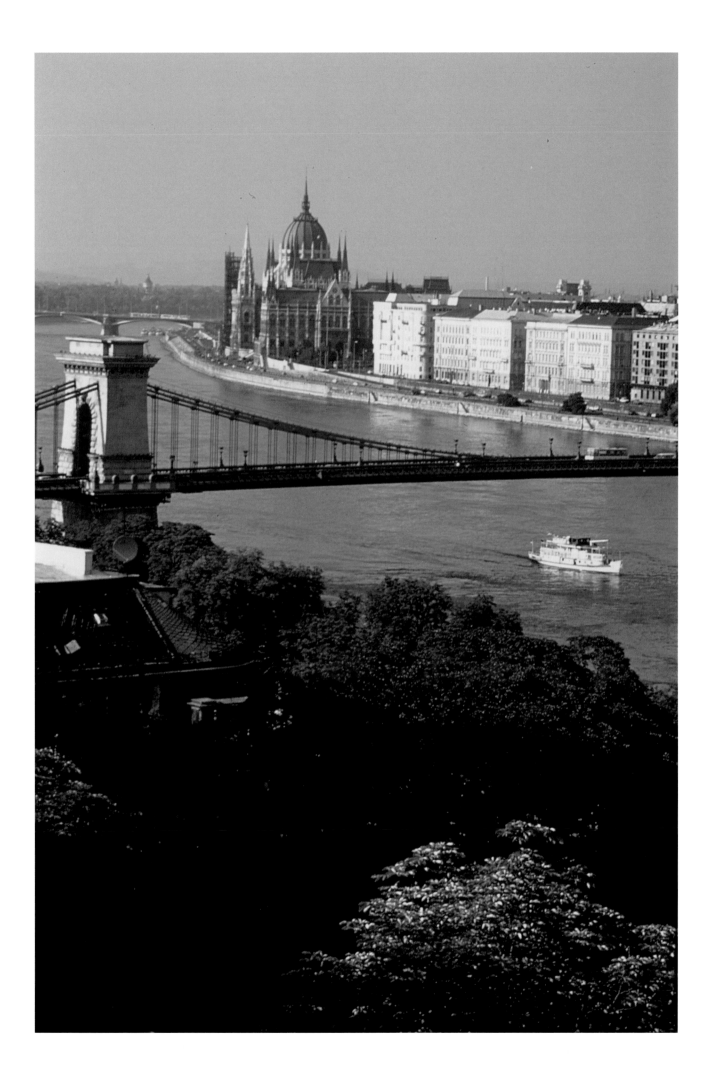

Religious Men – Katmandu, Nepal

These wonderful men are not poor, nor are they beggars. They were on the way to the temple when I asked to talk to them and take photographs. They had never seen Polaroids before, so when Luke and I developed them, they were thrilled. The entire village came to look over our backs to see the instant prints. After that, they waited as long as I wanted to photograph. Look at the last pages of this book to see the expressions of the town people looking at the Polaroid. What a grand moment in the crowd!

When I think of these men absolutely thrilled to see a Polaroid, it could be even more meaningful to them. Since I never saw a mirror in and around their city, there is a good chance that they have NEVER seen themselves! So what an honor to give them a print of their faces to see for the very first time.

Katmandu is one of the most interesting cities in the world for truly unique images. You will not leave the same person that you were.

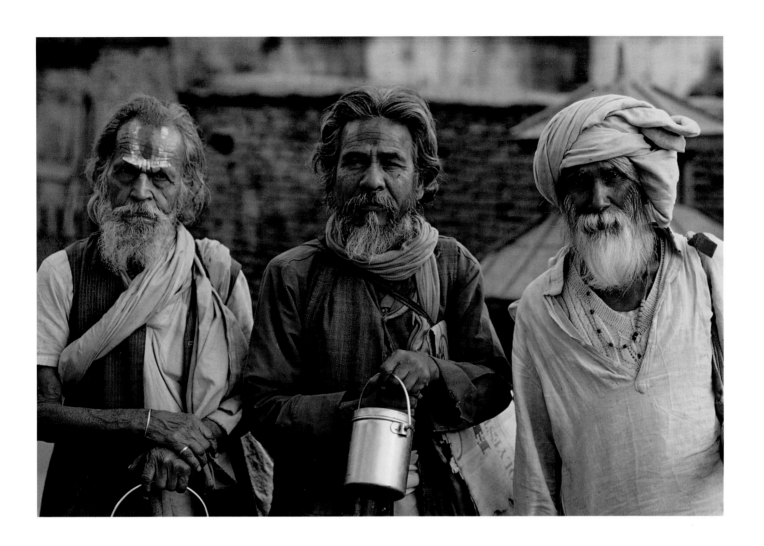

Woman Smoking – Kam Tin, Hong Kong

In this little walled city in the Northern Territories above Hong Kong, the women sit around all day smoking. They are not at all shy about asking for money for a photo.

I have visited this small village three times over the years, and I bring back photos to show and give to them. They really seem to appreciate seeing the photos years later. My last visit, I had a portrait with them (look in the very back of the book to see this humorous contrast)... they are probably half of my size, but I really enjoy their zest and fun each time I return.

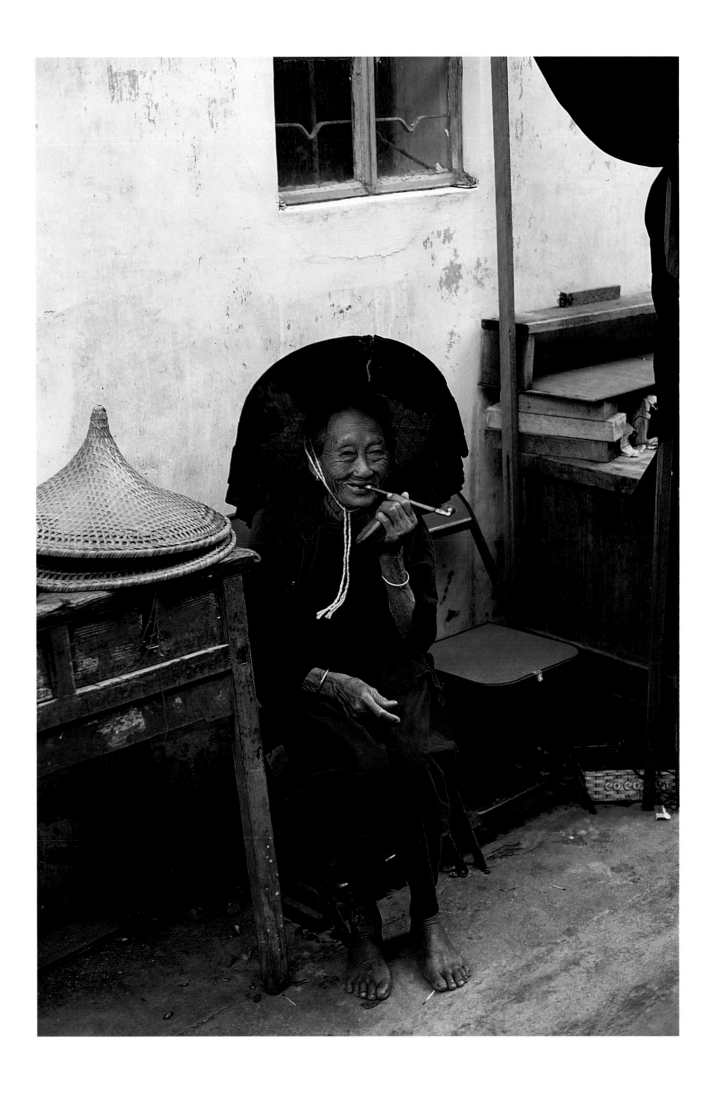

Outback – Australia

I spent three days in the Outback in Australia on this particular trip. Small bars in the middle of nowhere, and miles of desert and bush. I think I even met many of Crocodile Dundee's relatives!

To show the Outback in one photo was very difficult... there is very little there. I finally decided to use this empty scene illustrated to capture the feeling I experienced. From here to infinity... nothing.

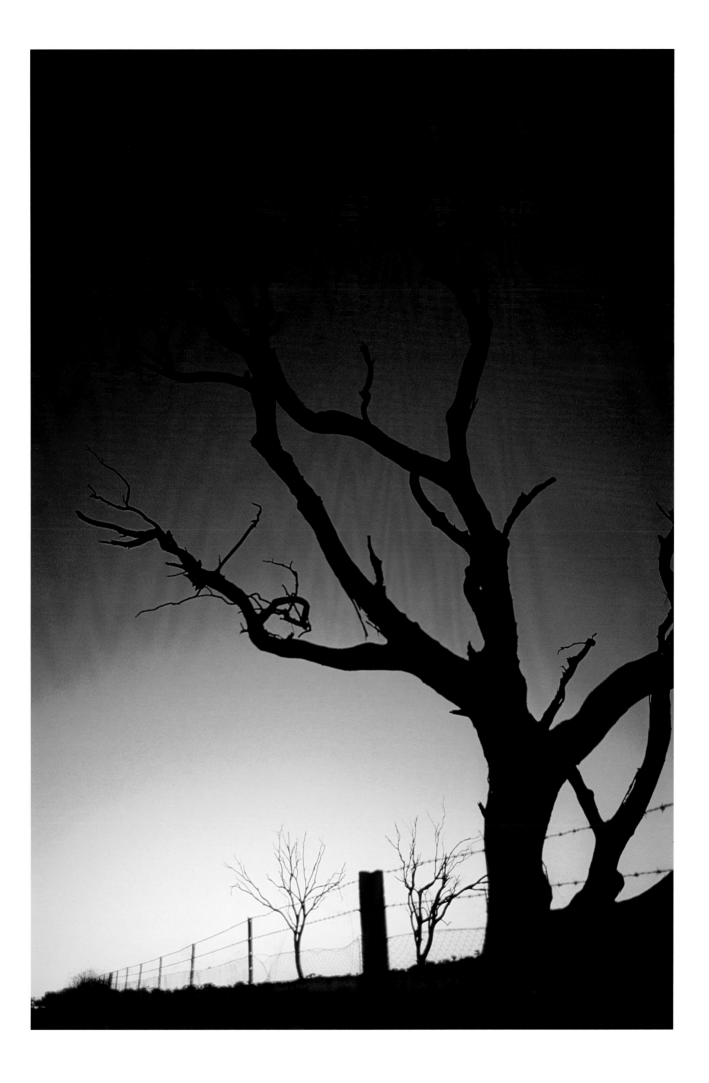

Traditional Dancers – Singapore

Unfortunately, there is very little tradition left in Singapore. Everything is glass, new and shiny, all prepared for shopping.

But I found a place that still had Chinese traditions, and I so enjoyed their performances. These dancers have simple Asian movements, much with their hands, and their beauty is unmatched. It is a joy to see some samples of history in this country that sadly seems to have forgotten its roots.

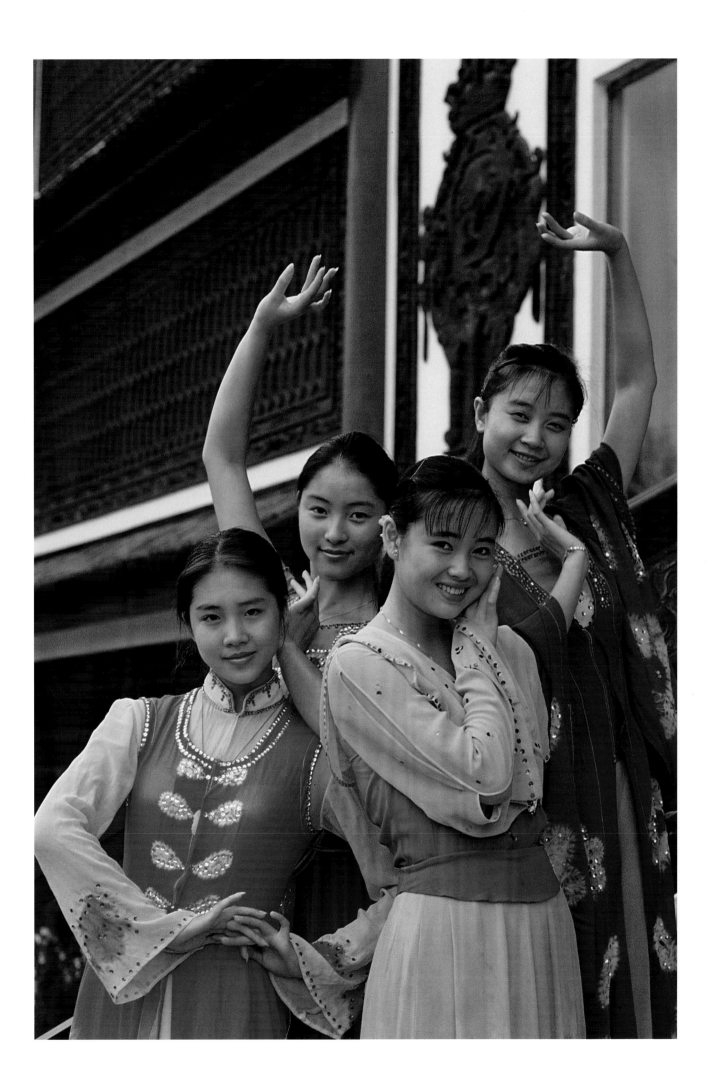

Braids – Katmandu, Nepal

This religious man had never cut his hair. His health was failing him, so he had come from his small town to the river to die. The river is Holy, and his goal was to have his ashes spread onto the water right after death... a journey to a better place.

He probably died days after this picture. To capture his spirit before he died was special to me.

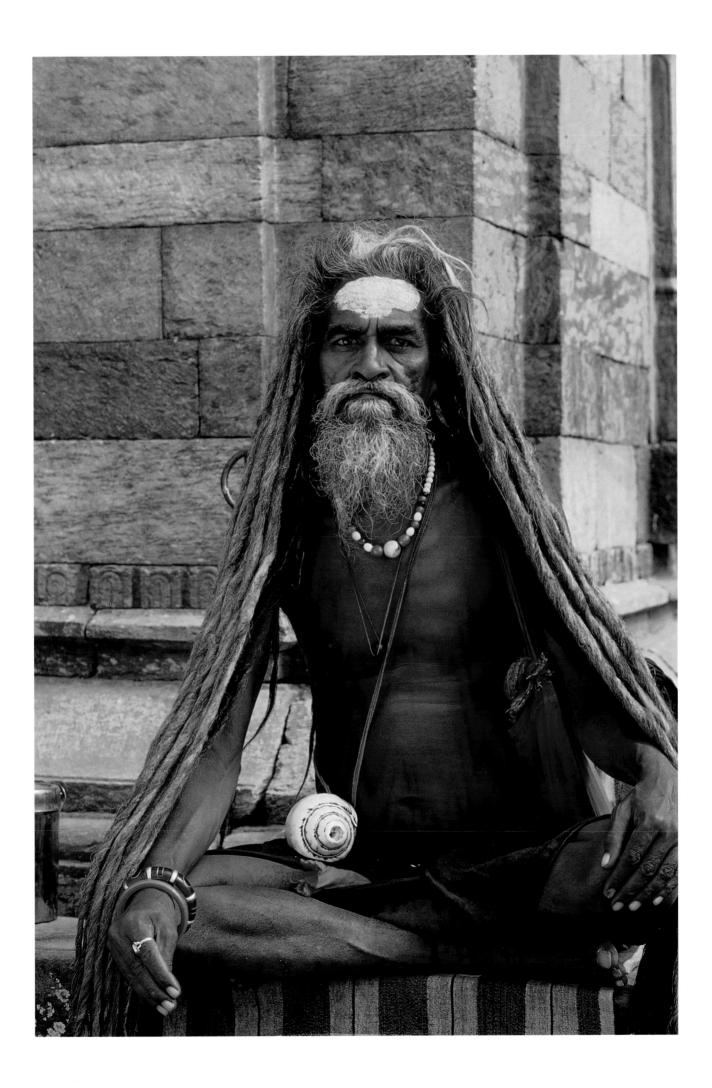

Covered Bridge – Vermont, USA

I love the way infrared film creates white trees in this artistic setting. This bridge could tell stories of New England teenagers sneaking kisses on horse-drawn carriages over the last hundred years.

Vermont has many covered bridges. Someday, I plan on staying long enough to film all of them.

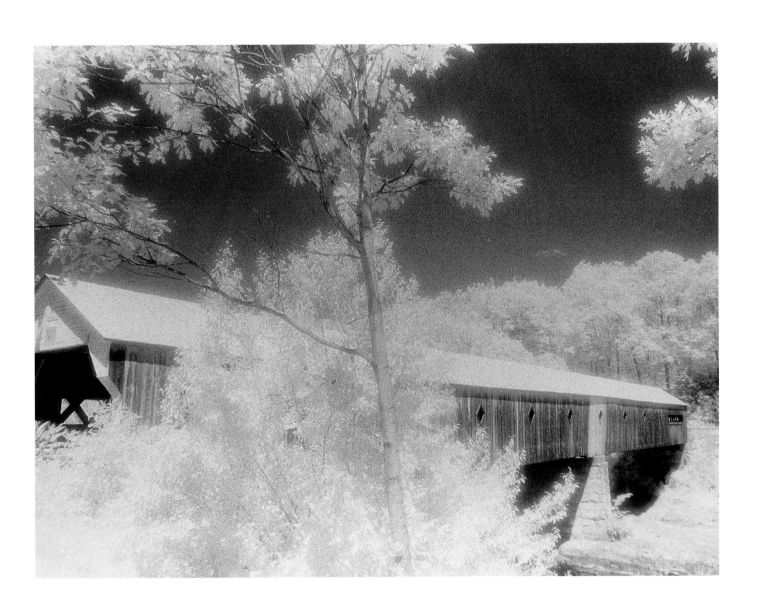

Gay Parade – San Francisco, USA

Part of the "Introspective World" that I have witnessed on my travels has been the diversity of people and lifestyles. Here, I shot infrared film to capture the gay dressers of a parade. The streets were lined with scenes one does not see on any normal day.

The best definition of San Francisco I have heard is ... "In San Francisco, Halloween is redundant!"

In this image, these men dressed as women and enjoyed parading for my cameras. I sent them photos and they sent letters back of thanks. It was a day of liberation for them, and I happened to be there with my cameras. The infrared helped to give it a dream feeling.

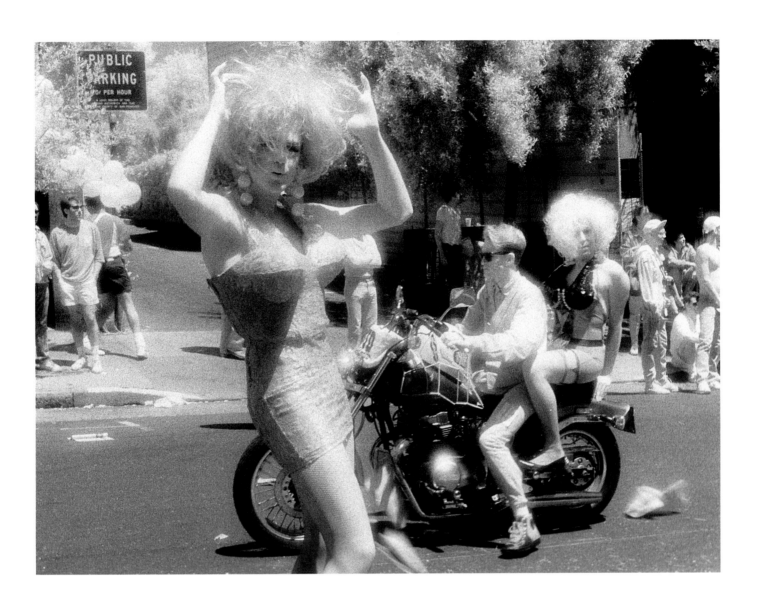

Teenagers – Moscow, Russia

I have been through Russia twice, once before and once after the overthrow of Communism. This image, captured after the overthrow, found Russia much more open, allowing personal freedom.

But, along with the freedom, Russians feel badly that they are no longer one of the world superpowers. Their money is worth almost nothing, so they sell everything they own. These teenagers are selling t-shirts, some with Western logos and Russian writing. This image has been featured in ads for World Cup Soccer; I sure wish I had the teenagers' addresses to send a copy of the magazine. They would be thrilled to have my photograph of them displayed as an advertisement in magazines of the United States.

I feel for the people of the former Soviet Union and trust that things will soon stabilize for the protection of the entire world. The instability in Russia today could easily become a major swing in the atomic warhead balance, or could create another "Hitler" type leader.

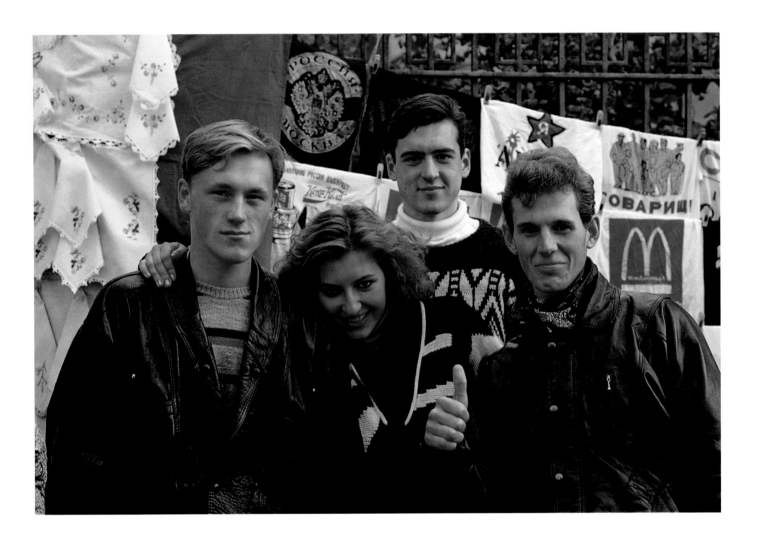

Colorful Dancers – Bali, Indonesia

The beautiful customs continue for centuries as these mysterious and graceful ladies dress for dance. The flowers in their headdresses are fresh each day. What terrific grace they possess.

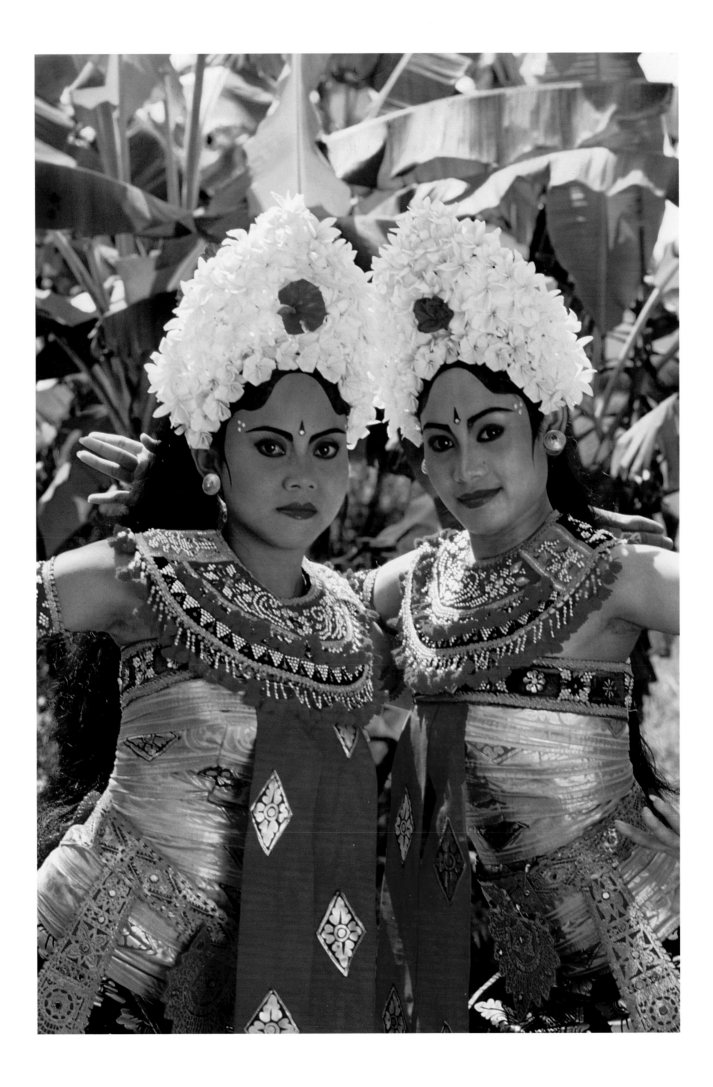

Layered Rice Fields – Bali, Indonesia

I thought I knew the color green... then I witnessed the GREEN of Bali! These fields have been plowed for centuries. What a lush and wonderful country to visit.

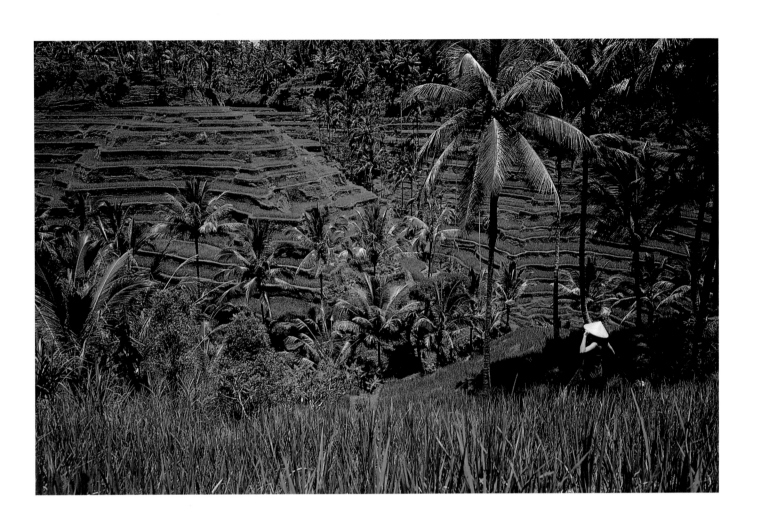

Muslim Woman – Cairo, Egypt

Despite all the "glamor" monuments and travel around the world, opportunities such as this are the main reasons I enjoy my experiences. I have so many chances to meet and photograph these wonderful, everyday people. This lovely woman may have little money, but her eyes show an immense pride and determination. And I love her tattoo.

I call this image "Earned Wrinkles", and I think it illustrates the struggle we all endure as humans. As I travel this world, I realize that all humans, rich or poor – civilized or not, desire the same basic needs. We want love, respect, shelter and safety for our loved ones. That never changes over all the borders on earth.

What we all need to learn is that our common ideals of humanity far outmeasure our cultural differences. If only all the world leaders would understand that more clearly!

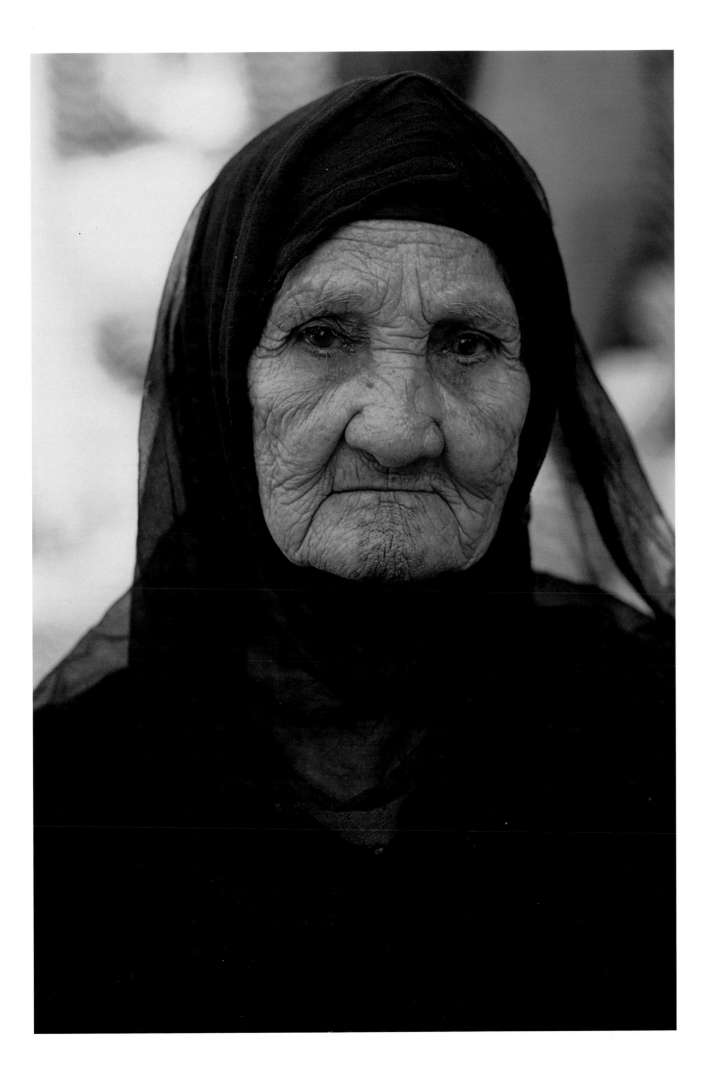

Sphinx – Giza, Egypt

The Sphinx is slowly decaying in the desert as it guards the Great Pyramids. Over 4,000 years old, the Sphinx still holds power and mystique in Egypt.

I met this Arab man and we talked for an enlightening hour. I then asked him to pose so I could capture the "Faces of Egypt."

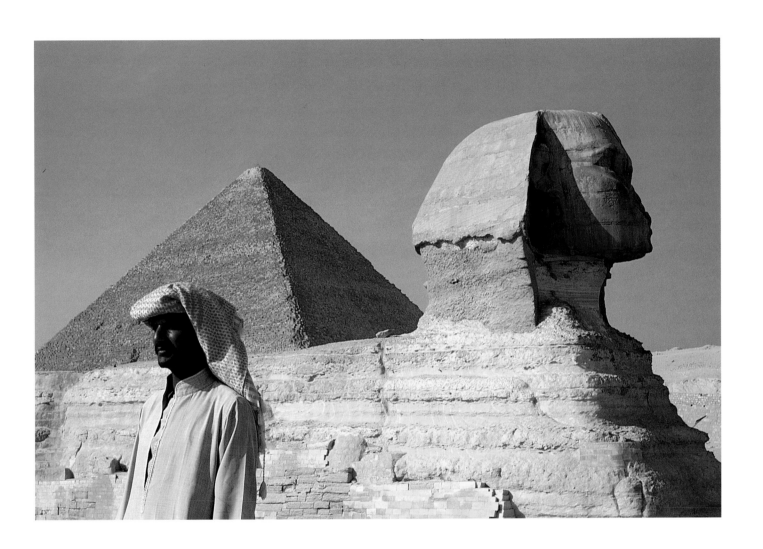

Monument Valley – Arizona, USA

The tree I discovered points towards the famous Mittens of Monument Valley. Indians live in the valley, and they appreciate the power of nature.

I waited for quite some time until the sun lit the scene as I desired. The tree directs the viewer's attention into the photograph.

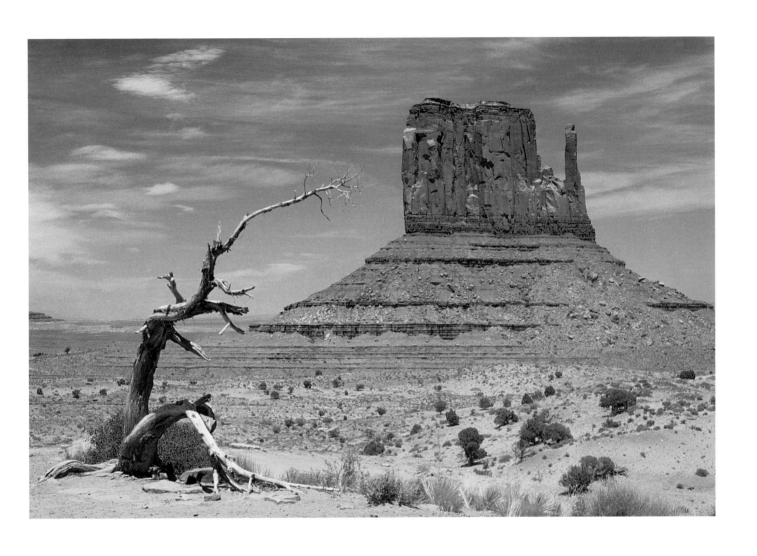

St. Petersburg, Russia

One of the most beautiful cities in the world, St. Petersburg has an illustrious past. After surviving the terror of 700 days of siege in World War II, when over one million people starved to death, the courage of the people surfaced. The city's name has changed... once known as Leningrad until recent demotion of the Lenin glory, it still shines as the "Venice of the North." Beautiful rivers wind in the city, while old classic buildings and churches have so much historical significance.

Sometime in your life, make sure you experience this gleaming city during the White Nights of summer.

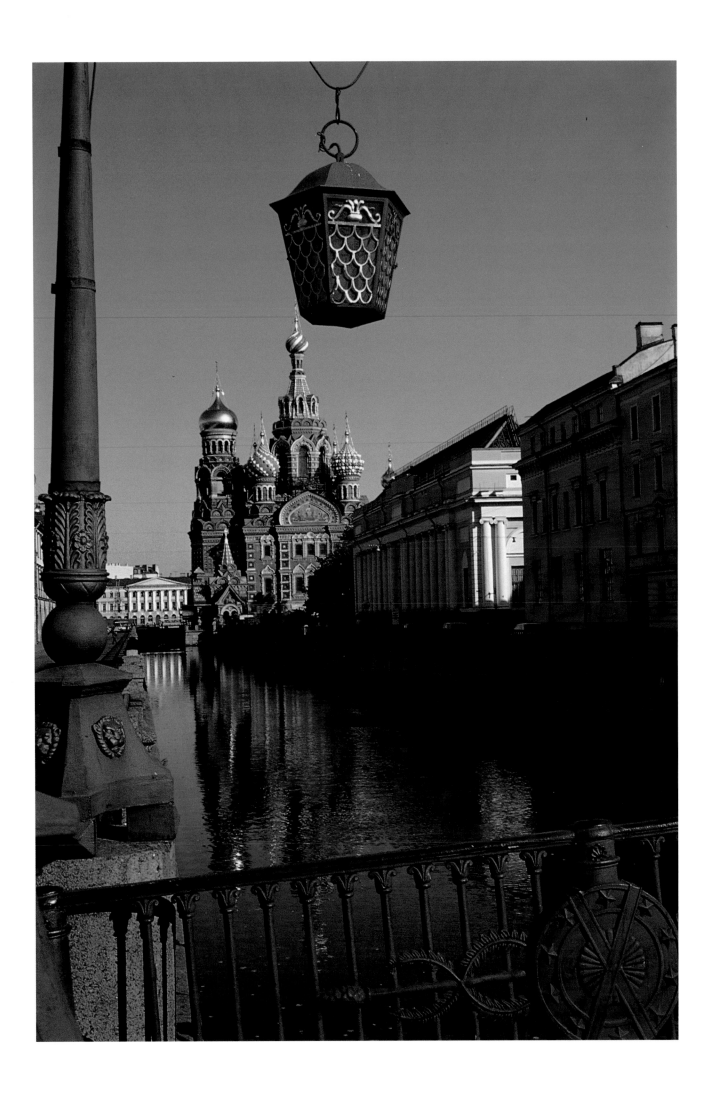

Floating Market – Damnernsaduak, Thailand

Three hours away from the city of Bangkok, this floating market offers everything imaginable paddling by on boats. You can buy anything in the world without leaving the water. This is how much of Asia used to be.

Next to this river you can see everything from snake charmers to televisions. And dinner goes slowly by for sale.

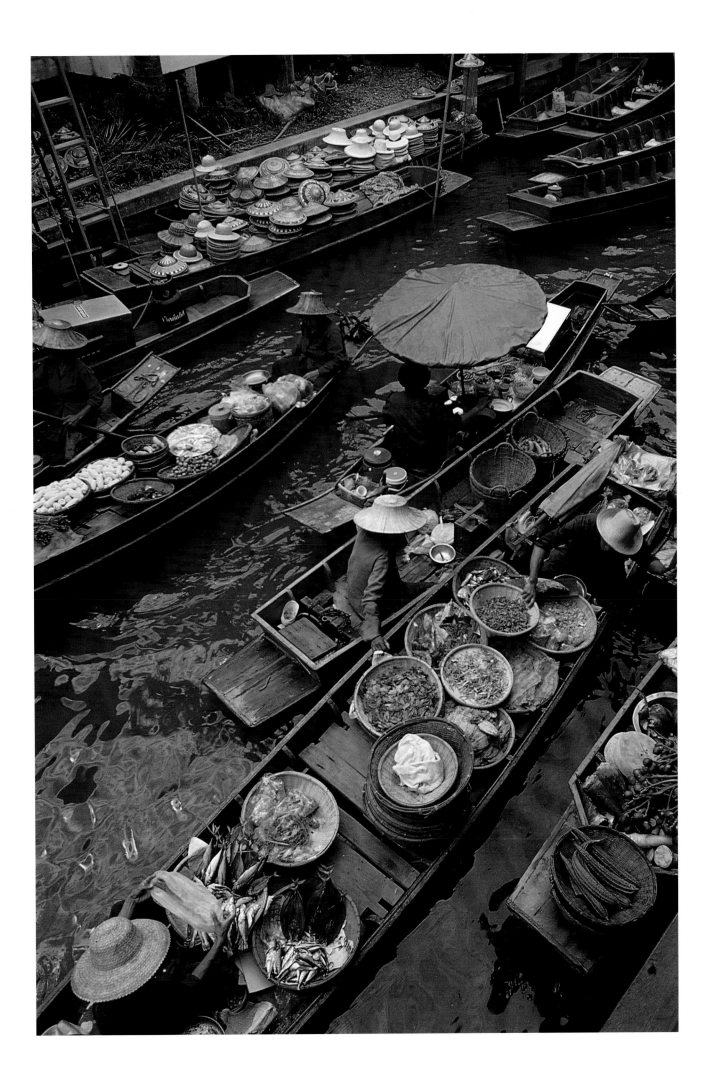

Woman with Babushka – Warsaw, Poland

Another wonderful face on my world travels. Warsaw has been a city of strength and determination... it was almost totally destroyed by the Germans in World War II, yet it never really surrendered. The pride in this woman's smile is what I was searching for in Poland.

I love her babushka and the mystery behind the smile. Shooting on the streets has been cleansing for the soul as I wander the countries. It will be difficult to return to shooting the "perfect" models for advertising.

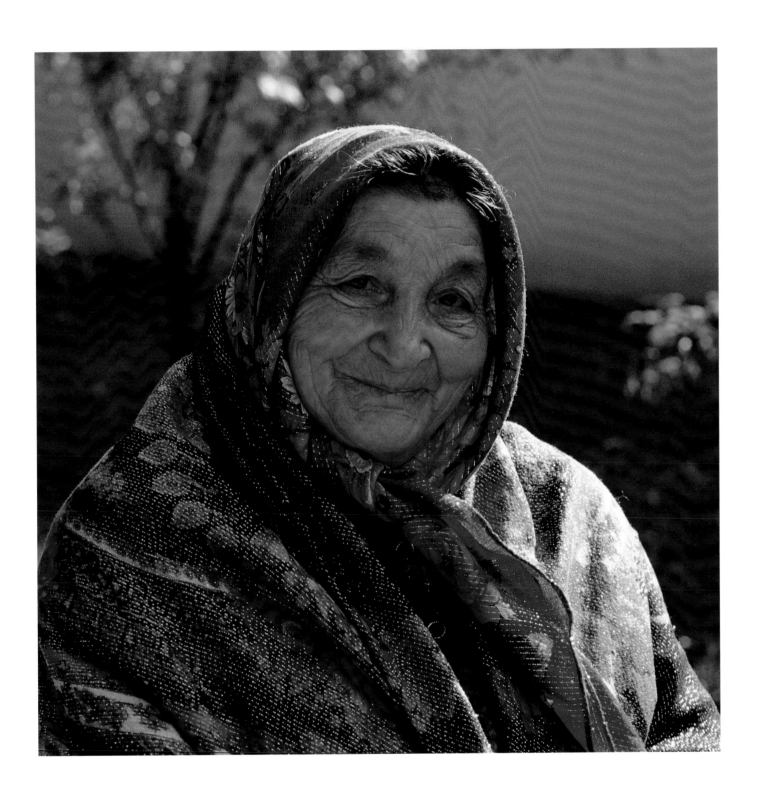

Snake Charmer – New Delhi, India

The streets of India are filled with photo opportunities. This charmer adds to the foreign sounds and flavors of this unusual country. Notice one snake has his jaw tied, and there is a ferret on the man's shoulder.

After spending considerable time in India, nothing surprises me anymore!

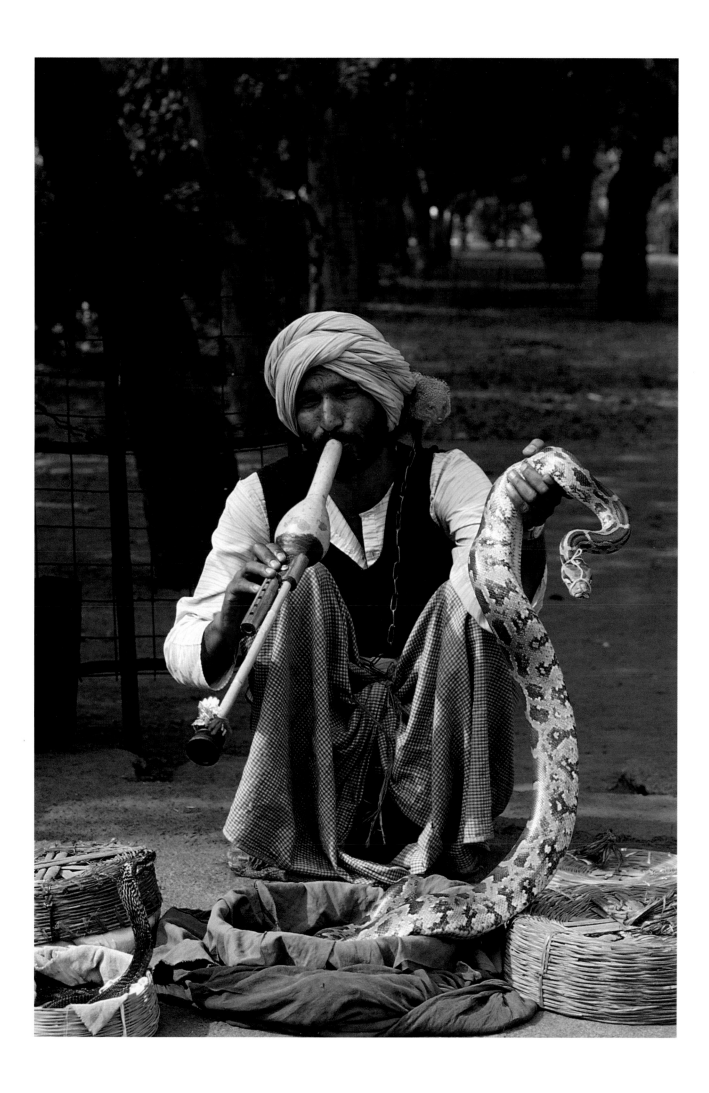

Himalayas – Near Mt. Everest, Nepal

In the country around Nepal, the villages are full of beautiful people. They are not poor; they have plenty to eat, and their lives are full. I was impressed with their outlook on life.

I love the golden feel of this photo, as I bounced light back onto her baby. These people are warm and caring, surviving in a really tough, interesting part of the world.

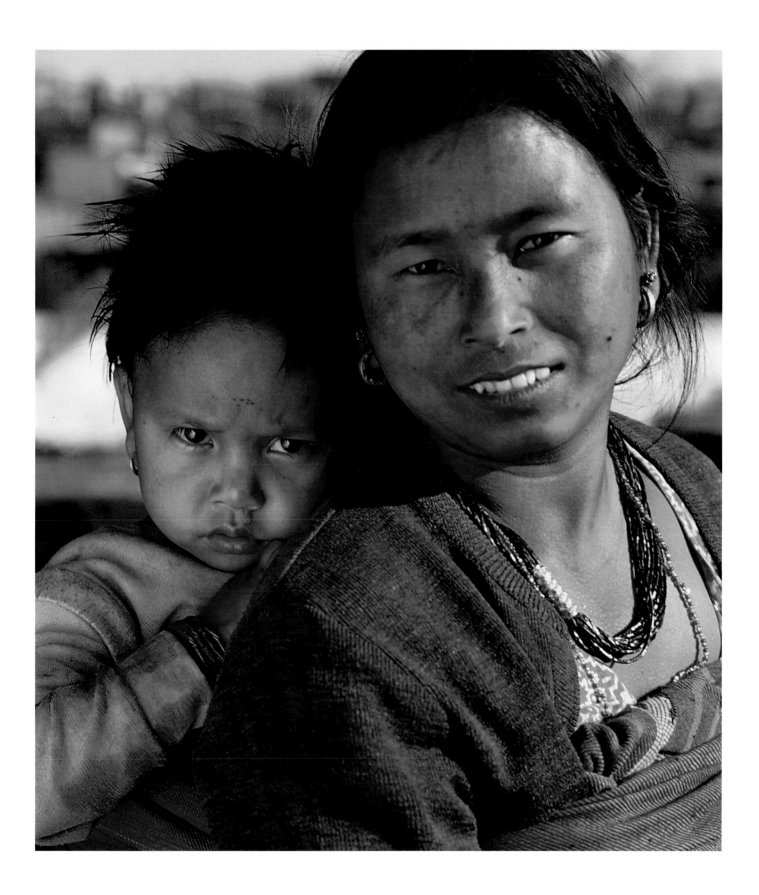

Red Square – Moscow, Russia

This is the square where Russia intimidated the world. On May Day, they would flaunt their missiles and power to the West.

Now, even after the breakup of the Soviet Union, Red Square still seems to hold its power. Military men with briefcases still bring fear to the people. And, all the while, St. Basil's Cathedral stands as a monument to times past.

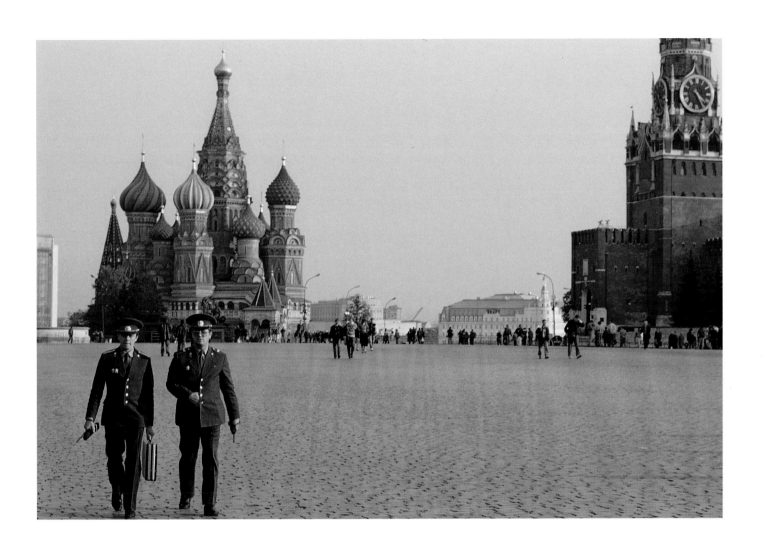

Market – St. Petersburg, Russia

The people in Russia have absolutely nothing since the new democracy. Inflation is 400%, wages are minimal, and everything is for sale.

This tomato salesman's expression says it all. Hoping that time will heal the problems, each person sells enough to get by that day.

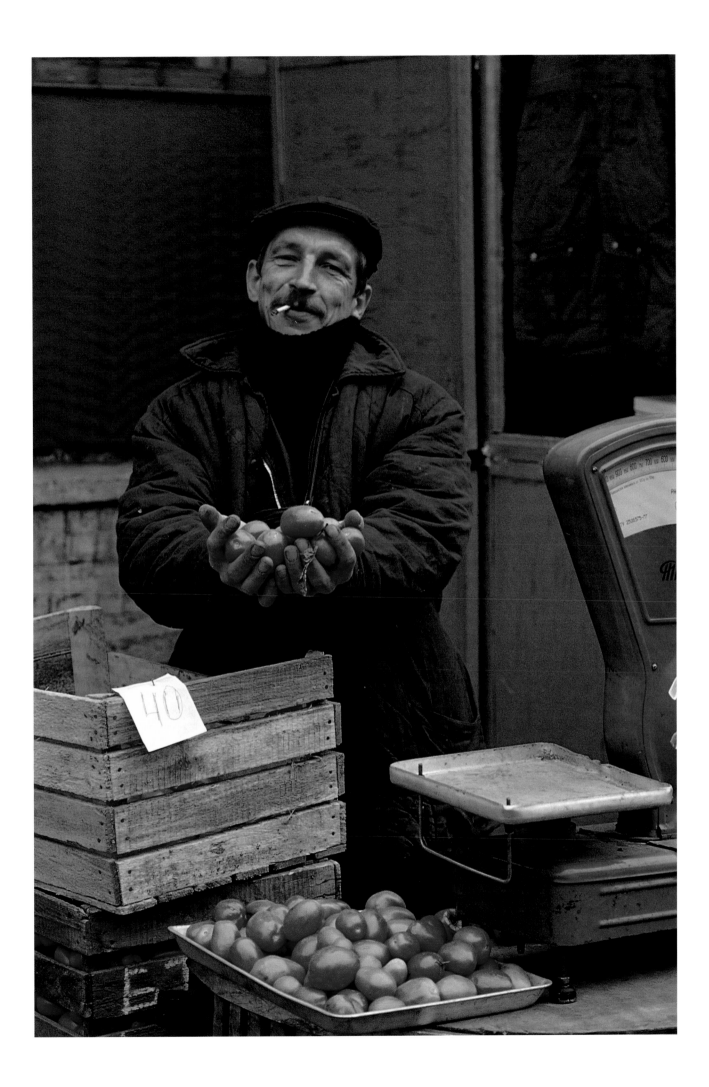

Waikiki Beach – Honolulu, Hawaii

The most famous beach in the world at sunset. We often forget how nature alone can be beautiful. Palm trees and water at sunset will always represent peacefulness and relaxation.

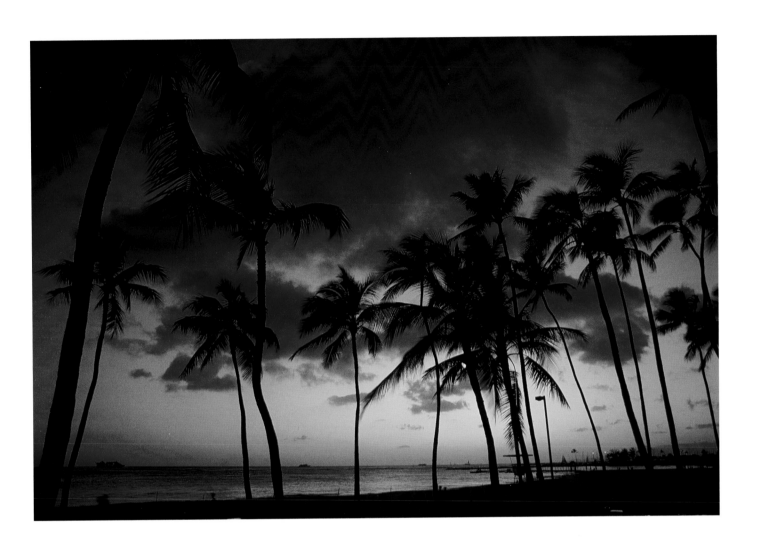

Waterfall – Glacier National Park, Montana

This peaceful waterfall image is taken in one of the most beautiful spots in America. I slowed the camera shutter to allow the water to gently flow in front of me.

There was a mist in the air, and the camera captured all the details of the rocks. The Black & White prints that I photographed here were used to create an Ansel Adams-type poster for the book. It became the award-winning poster that I carried around the world, to have autographed during my World Tour adventure.

I really enjoy the peace this image brings, when framed in the home.

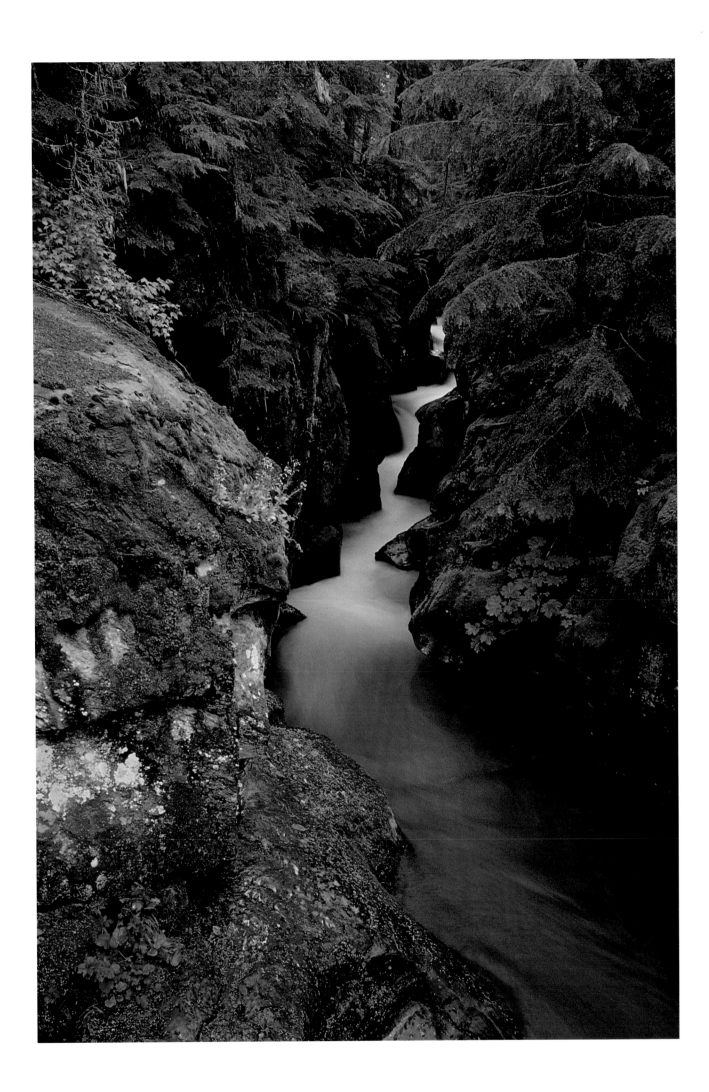

Vegetable Market – Shanghai, China

The city of Shanghai is old and full of charm, streets crammed with vendors hawking their exotic treasures.

I enjoyed this man as he weighed his food with the most elementary of scales. And, of course, the cigarette... most of Asia smokes. Our cigarette companies, hopefully getting chased out of the USA, are gearing up for all the competition – and 2 billion people – in Asia.

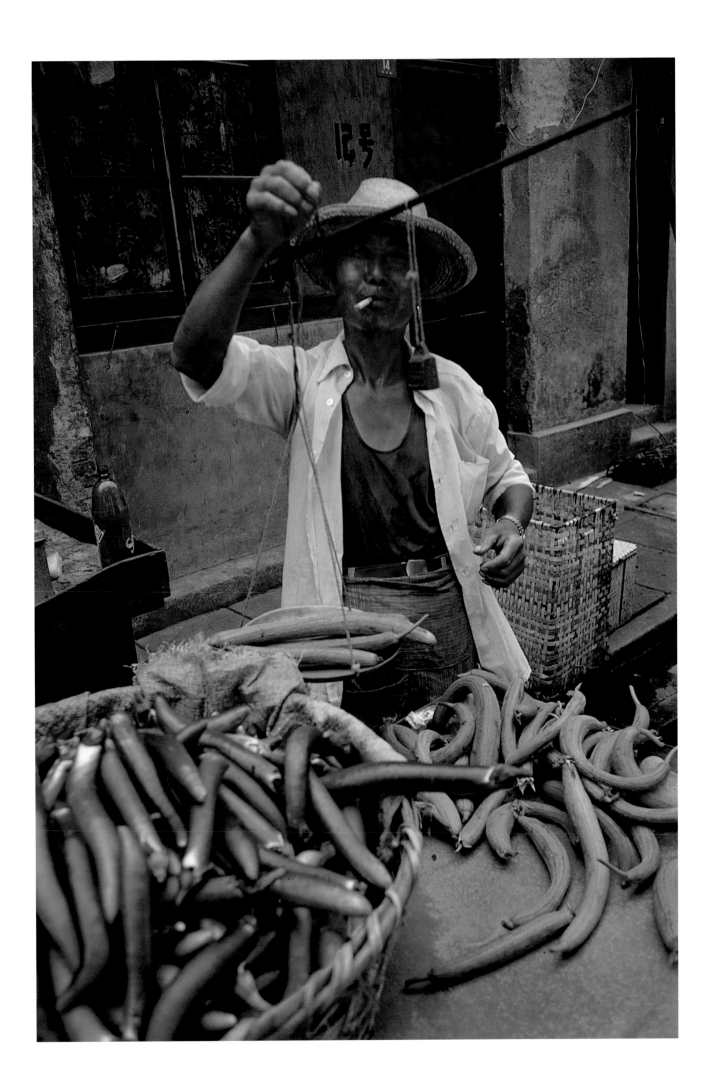

Fruit Market – Grenada

Grenada is a country that absolutely loves America. When we dropped bombs to get the Cubans out of their small island, we became heroes. They all remember where they were when America liberated them.

It becomes clear why we dropped the bombs, and what the Cubans were planning to do there, when visiting the huge airport that was built. All the other islands have small runways – in Grenada, the Cubans had built giant runways to make the island a major landing area for troops.

You see graffiti on the walls everywhere stating, "We love the USA." It's refreshing to see these signs.

For this photograph in Grenada, I didn't want to disturb the market. I didn't even clean the litter. I just attempted to show the color and action in this interesting fruit market – a view from above.

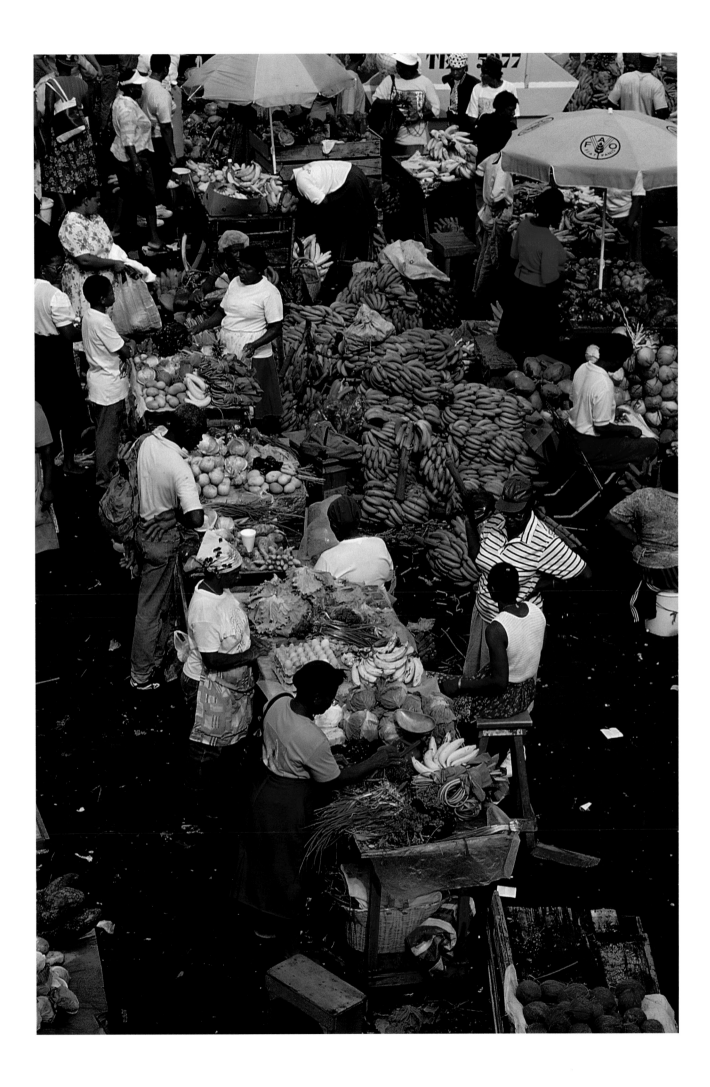

Worthington Glacier – Valdez, Alaska

Since I've traveled to over 100 countries in the world, people often ask me for the most beautiful place I've seen. It's a difficult question to answer, but my answer for an entire country is New Zealand. The most beautiful place, however, is definitely Alaska.

Alaska is so vast, diversified and possesses such raw beauty. Seventeen of the 20 highest mountains in the USA are in this huge state. The best part is you can actually drive among many of them.

The photograph I decided to include in this book portrays that ability to drive so close to spectacular scenery. I stood in the middle of the Richardson Highway and created the "road to Alaska" feeling.

People who live in this 49th state are a rare combination of renegade and loner. This rebellious spirit must have infiltrated me as I decided to drive a rented, four-wheel drive Jeep (I would never have taken my own!) and traveled to the "Top Of The Earth". I drove past the highest paved road in the world, and went 400 plus miles over potholed dirt roads, far above the Arctic Circle, to the top city on our earth. What a grand experience!

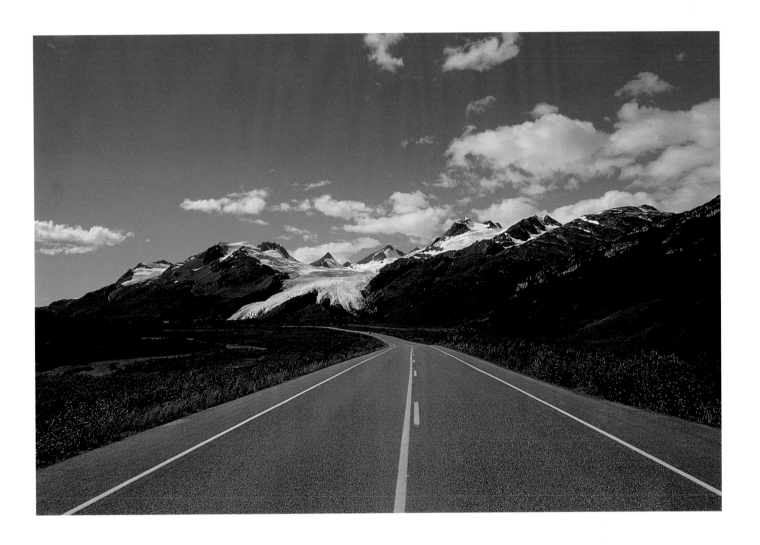

Will I Ever Get A Real Job??

My best reception ever to a Polaroid... this Maasai tribe in Kenya, Africa was overwhelmed by their first-ever print. I'm sure it's pinned inside their huts. *(photo: Luke Potter)*

Sand dunes in the 120 degree heat of Death Valley. An absolutely unforgettable experience.

How I spend much of my time... waiting for just the right light on some beach of the world.

"The Top Of The Earth"... crossing the Arctic Circle in Alaska.

Mozart Festival in Vienna, a city that exudes classical music.

Luke and me on our trip in the Himalayas, Nepal. A cloudy Mt. Everest is in the background... another "Top Of The Earth."

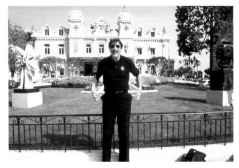

"Broke" after some time in the famous Monte Carlo Casino in Monaco.

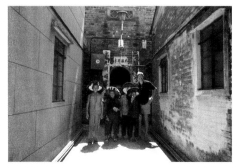

My first portrait with the little ladies in the walled city of Kam Tin, China. I've been there three times, and these women – half my size – remembered me.

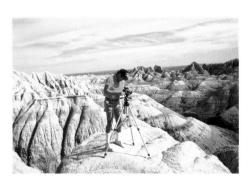

Shooting in the Badlands of South Dakota. If ever a place earned its name...

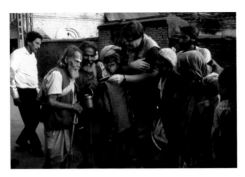

Sharing a Polaroid with men, who have never seen one, in Katmandu. The entire town came out to see it.
(photo: Luke Potter)

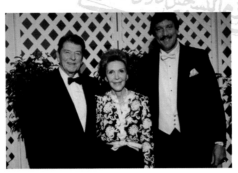

Part of the Introspective World that I have photographed includes celebrity shoots. I've worked with the Reagans twice, and with three other Presidents.

Eight-hundred feet underground in Carlsbad Caverns, New Mexico. Trying to determine which are stalagmites.

Perched on a cliff at sunset in Greece, shooting panoramics of the Acropolis.

Olympic Stadium in Seoul, Korea. Carrying the Olympic torch… OK, it's my umbrella.

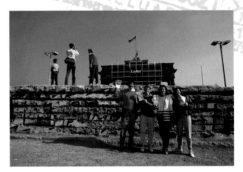

Berlin Wall when the horrible Wall finally came down. Spelling out "FREE" with celebrating East German students.

Riding a camel in Malaysia. I don't think either one of us enjoyed the ride!!

Shooting the splendid skyline of Hong Kong from the harbor. One of my favorite cities in the world.

"Asia–The End." From the hospital bed in Singapore, when my appendix ruptured, on one of the legs of the World Tour. A scary time.

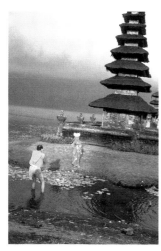

So this is a glamorous profession?? Knee deep in mud at Lake Bratan, Bali. *(photo: Luke Potter)*

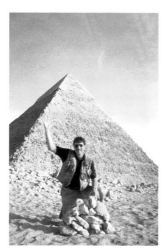

Building my own pyramid at the Great Pyramids in Egypt.

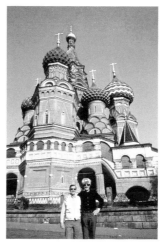

Luke and me in Red Square at St. Basil's Cathedral in Moscow.

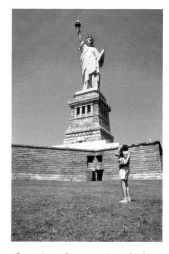

Shooting the prettiest lady in New York.

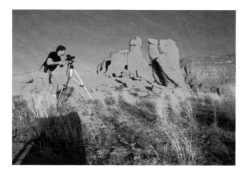

Sunset at Baby Rocks, Arizona... that 'golden light' time to shoot.

Puzzled by the largest lobster in Maine.

Wonderful icebergs at Columbia Glacier in Alaska. It's difficult to describe the many wonders of this fabulous state.

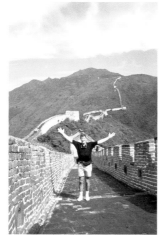

Standing alone on one of the greatest sights on earth – the Great Wall of China.

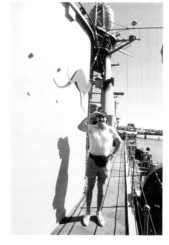

Invited to explore an Australian submarine in the Land Down Under.

Is this how we file our slides?

Acknowledgements

It would be impossible to thank all the people who have helped make this book become a reality. I am surrounded with a wonderful support system in my work and life... this group of people have blessed my life and allowed me the freedom to explore.

As I stated before, the person responsible for much of the World Tour is my friend, and fellow photographer, Luke Potter. I thank him again here for traveling the many miles, with many smiles. And we both thank Kodak, Hilton, and Marriott for making the journeys so pleasant indeed.

John Randle was the graphic designer of the book, and I thank him for the long hours we worked together over the computer. My thanks go to my two editors, Vicki Stuart and Cindy McCormick. They made sure that all the loose thoughts were neatly tied together. Phil Parker at Wace Photo Imaging developed all of the films on my many trips, and helped with CD-Roms of the photos for the final book form. Wace is a great photo lab, and has been my partner on several important projects, and I thank them for always being there.

George Ducker, Chris Welch and the crew at Moran Printing Company in Orlando printed the book, and did all the film separations and prep. This is my second book with them, and I will continue to come back for their fine work.

Penny Stone of Lake Mary Travel did all my scheduling on the World Tour. I constantly give Penny impossible itineraries, and she comes through for me time after time. I thank my good friend Slade for his great friendship and public relations help. Slade knows everyone, it seems, and somehow gets me to meet them.

I thank a fellow photographer, Peter Langoné, for his creative ideas as I formed the book in my mind. In our friendship, Peter has a way of cutting to the core of my ideas and refocusing my energies... I value his insight. I receive much encouragement from another fellow photographer, Dennis Salvagio. Dennis has a pure love for photography (even though he's an attorney in real life!), and this zest often inspires me to greater heights.

To all my stock reps for believing in me, and for sending my images to magazines all over the world. These great relationships with them allow me to be free to shoot what I love, knowing they will find the international markets for the photographs.

My warm thanks go to Diane Yontz, Rose Poole, and Cindy McCormick for all taking care of the studio business while I travel. It's so comforting to know that

they were here in Florida returning calls and meeting clients, allowing me to be on some remote corner of earth.

In my personal life, I would also like to thank special people who have influenced me. We go through life touched by the people who nurture us with their love, inspiration and concern.

To my parents, Ernest and Helen Bachmann, for giving me so much love and space to grow. My Dad's gentle spirit lives in me each day, as does my Mom's motivation and determination. As I grew up, my Dad never placed walls in front of me – only doors – and it is a wonderful way for a young person to develop freedom and decision making. I am a proud product of both their genes and nurturing.

To Ruth, my Soulmate for many years, for allowing me to explore the depth of feelings in my heart. Our relationship was joy and growth for both of us. To Judi, a very special person in my life, for being there with warmth and understanding as I returned from many trips. You always made home feel so comfortable.

For my wonderful Aunt Ady and her gentle spirit that I so often have appreciated my entire life. Her wisdom and advice has always been there when I hit forks in the road of life.

For Connie and Paul Beals, and their children Kim and Richie, my best friends in the world. You have often traveled with me around the world, and the richness of our love and friendship gives our lives such added zest.

And, finally, to all of the art directors and assistants I've worked with over the years. You've shared your lives and memories with me, and I deeply thank you. We've sure had some grand experiences in this wonderful profession of photography, haven't we?

Some thoughts...

The window is not the view; the window allows the view.

In a lifetime I will lay eyes on thousands of human beings, across rooms, on the streets, inside buildings. What will come of it? Absolutely nothing. Unless I change my attitude, they will remain a part of the dull background.

Thought directs the eyes and eyes direct the soul.

Are there any wholly useless encounters? I know this: there are no insignificant people. There is no one who isn't supposed to be there.

There are people whose feelings and well-being are within my influence. I will never escape that fact.

Hugh Prather

I hope that this book, and the many thoughts expressed throughout, in some way touches your own visions and sensitivities.

Bill Bachmann